strawberries
50 TRIED & TRUE RECIPES

Corrine Kozlak
photography by Kevin Scott Ramos

PUBLICATIONS
Adventure
an imprint of Adventure**KEEN**

Cover and book design by Jonathan Norberg
Edited by Emily Beaumont

Cover images: All images by Kevin Scott Ramos.

All images copyrighted.

All images by Kevin Scott Ramos unless otherwise noted.

Used under license from Shutterstock.com:
fredredhat: 14; **Brent Hofacker:** 74; **topseller:** 4; **Miss Ty:** 7

10 9 8 7 6 5 4 3 2 1

Strawberries: 50 Tried & True Recipes
Copyright © 2023 by Corrine Kozlak
Published by Adventure Publications
An imprint of AdventureKEEN
310 Garfield Street South
Cambridge, Minnesota 55008
(800) 678-7006
www.adventurepublications.net
Printed in China
LCCN 2022036992 (print); 2022036993 (ebook)
ISBN 978-1-64755-280-0 (pbk.); ISBN 978-1-64755-281-7 (ebook)

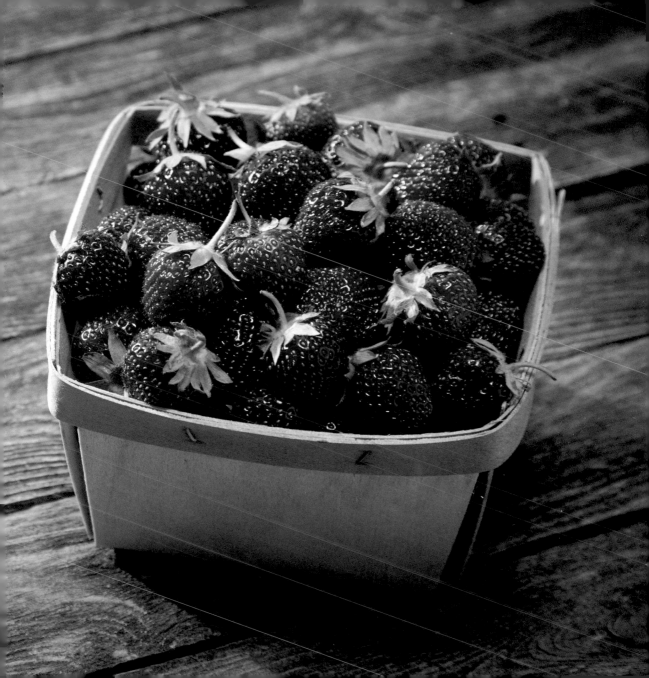

Acknowledgments

I would like to express my gratitude to all who contributed and helped me create this cookbook, especially the following:

A big thank-you to Kevin, for working me into his very busy photography schedule, sharing his many skills, and taking part in many hours of post-production edits.

My family: Dan, Danny, Callie—and her new husband, John Tyler—a new taster for this cookbook. They have eaten many strawberry-centric meals at breakfast, lunch, dinner, and, of course, for dessert.

To my parents, for finding and gathering their favorite handwritten strawberry recipes. They also found many strawberry recipes in their life's collection of community cookbooks compiled by friends—a great source of tried-and-true recipes.

To Mara, who shared her recipe and wisdom for making Strawberry Freezer Jam (page 45). This family tradition starts with a trip to a pick-your-own strawberry farm and finishes with enough freezer jam to enjoy for breakfast all year long.

My girls once again came through with many of their favorite strawberry recipes. Karen's Strawberry Tres Leches Cake (page 115) has become one of my favorites as well.

I have a new appreciation for all the many seasonal strawberry farmers out there. There is nothing easy about farming! There are so many variables: rain, frost, insects, and a short growing season, to name a few. Rewards are few but delicious.

strawberries

50 TRIED & TRUE RECIPES

Table of Contents

Preface

Like the famous Beatles song, you can see "Strawberry Fields Forever." And everywhere around the world, strawberries are one of the most popular—and consumed—fruits. Strawberry production is a multibillion-dollar industry that ranges from small pick-your-own farms to huge industrial farms, not to mention countless home gardens.

Strawberries are grown worldwide, with China and the United States as the top producers.

Better yet, strawberries are good for you! One serving contains more than half of the daily recommendation of vitamin C, as well as important trace minerals. In this cookbook you will find 50 delicious, tried-and-true strawberry recipes with current cooking and baking trends considered and included.

Enjoy!

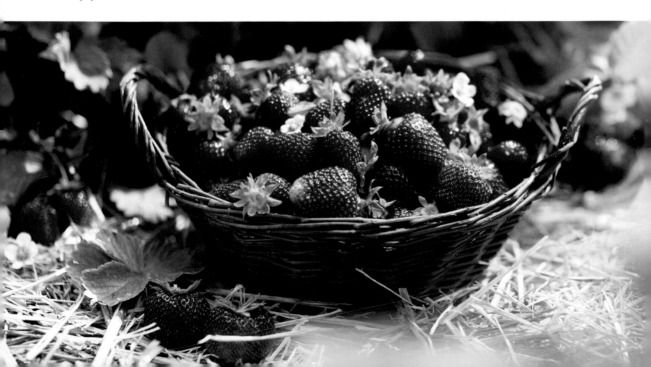

History

For such a familiar fruit, strawberries have something of a convoluted history. First off, strawberries aren't technically berries—they are what's known as a receptacle and the "seeds" are actually their fruit. Botanical definitions aside, strawberries are found in Europe, Asia, and North America, among other places. Our modern strawberries (*Fragaria x ananassa*) are a cultivar of two different varieties, the Virginia Strawberry (*Fragaria virginiana*) and the Chilean Strawberry (*Fragaria chiloensis*), both of which are native to the United States. Compared to their wild relatives, cultivated strawberries are much larger and firmer.

The English word "strawberry" has something of a confusing history. There are several different theories about how the fruit got its odd name. Some argue that the name pertains to cultivation somehow involving straw, but the name is much older than cultivation. Another suggestion is that strawberries are "strewn" around the ground and often found amid grasses, which eventually combined to produce "strawberries."

Strawberries are more than just a simple food—there are myriad cultural and symbolic associations with the fruit, whether it's references in Shakespeare (*Othello, Richard III*), the Beatles, or kiddos carrying around their Strawberry Shortcake dolls. Generally speaking, strawberries are largely viewed as a good—even pure—food, and their popular reputation reflects that.

Strawberry Cultivation and Consumption in the US

Strawberries are cultivated in many states, with California and Florida as the top producers. The average production per acre in California is a whopping 68,000 pounds (34 tons). The US produces an estimated 1.1 million tons of strawberries each year, with a per capita consumption of about 4.8 pounds; about 94% of all households in the United States consume strawberries.

Strawberry Nutrition

Strawberries are nutritional superstars, famous for their vitamin C. Strawberries have more vitamin C per cup than an orange. Vitamin C may lower cancer risk and prevent age-related vision loss, among other benefits. Strawberries contain potassium; manganese; iron; and folate, a B vitamin that's important for cell function. Strawberries also have soluble and insoluble fiber that helps regulate blood sugar and support good digestion. The rich red color of the strawberry comes from anthocyanins, which have an antioxidant effect. You will find my delicious, super-healthy Strawberry, Mint, and Lemon Water Detox Drink on page 37. One more thing: there are only 36 calories per 1 cup of unsweetened strawberries, and they are gluten-free and almost fat-free.

Nutrition Facts

100 grams (1 cup sliced): 36 calories

Protein: 0.64 gram

Carbohydrates: 8 grams

Dietary Fiber: 3 grams

Sugar: 5 grams

Potassium: 161 mg

Vitamin C: 60 mg

Calcium: 17 mg

Magnesium: 12.5 mg

Phosphorus: 23 mg

Lipid (fat): 0.22 g

Courtesy of the USDA and FoodData Central: https://fdc.nal .usda.gov/fdc-app.html#/food-details/2263887/nutrients

How to Grow Strawberries

Strawberries are one of the most popular fruit plants. Strawberry plants are fairly easy to grow and are prolific under the right conditions.

There are three general kinds of strawberry plants: June-bearing, everbearing, and day-neutral. June-bearing plants produce a lot of berries in June, as their name suggests. Everbearing crops produce two crops (one in early summer, one toward the end of summer). Day-neutral plants are a bit different, as they produce fruit as long as it's warm enough for the plants to survive. Within these groups, there are many different varieties to choose from, so check with your local garden club or horticultural society experts for the best plants for your area.

Buy small plants or plugs, and plant them early in the spring. It is also recommended that you pinch back the initial flowers until the plant is established. Strawberries need nutrient-rich, well-drained soil; nitrogen-rich fertilizer; and sun. When planting bare-root plants, remove packaging, and then trim roots to around 6–8 inches, as needed. Then soak the roots in water for 10–15 minutes and plant the crowns at soil level. Water well and mulch with clean straw. Keep weeds and grass out of your strawberries. Strawberries are capable of self-pollination, but they also get pollination help from wind and, of course, insects.

Strawberries put out runners, which are long, vine-like shoots with little baby crowns and roots at the end of the runners. If you keep them, you get more plants. Some people cut back the runners because they can reduce strawberry production and drain the mother plant.

Strawberries need a constant moist environment, but they don't do well in standing water. At least 1 inch of water is needed weekly, whether through rain or watering. When the fruit is forming, more water is required. Mulching with straw protects against the heat and cold. Watering should continue through the summer, especially if it's hot or dry. Late-season watering will affect the next year's fruit.

Winterizing your strawberry plants depends on your climate and the hardiness of your particular strawberry plants. Most plants live for a few years. When it starts to get cold, cover them with... you guessed it...straw!

Choosing and Storing Strawberries

Because strawberries don't have a peel or a hard shell, they are vulnerable to bruising and mold, and they have a short shelf life, even with refrigeration. Freezing and preserving them (below) lengthens their shelf life, but it also changes the structure of the berry.

Select firm, fully red berries; strawberries do not continue to ripen after they are picked. When buying strawberries, check for any growing mold. Do not wash or hull strawberries until you are ready to use or eat them. It is best to refrigerate them in the containers you buy them in. The best temperature for storing strawberries is 32–36 degrees Fahrenheit, with a 90–95% humidity level. If you have a crisper drawer in your refrigerator, store them there. Examine the container often and remove any moldy strawberries.

Preserving Strawberries

Handle the berries as little as possible. I have noticed that commercial strawberry growers pick and put the fruit directly into the plastic containers you buy them in. In an attempt to keep strawberries fresher longer, I have experimented with dipping the berries in vinegar water, placing them on their leaves on paper towels in a container, and allowing them to dry completely. The acidity in the vinegar kills fungi and other unwanted organisms, helping the berries stay fresher longer.

Freezing berries is another option; it extends the life of strawberries by as much as a year if sweetened, eight months if not. Freezing changes the texture of the strawberry. When you freeze strawberries, the water in the plant cells freezes, and the resulting ice crystals cause the cell walls to rupture. Some recipes are better with thawed frozen strawberries, as they will be darker and softer. Thawed strawberries also render a lot of juice.

To freeze strawberries, choose fully ripened fruit; wash, sort, and de-cap. Whole individual berries can be put on a sheet pan and frozen, then placed in zip-top plastic freezer bags or containers of your choice. That way you can remove the amount you want and use the rest another time. About ⅔ of a quart of fresh strawberries will produce about 1 pint of frozen berries. Having frozen strawberries on hand is wonderful if you need a last-minute dessert.

Sliced, halved, crushed, or pureed strawberries can also be frozen, as can the juice. It is helpful to label your container with the amount and date frozen. This will help you identify that mysterious frozen block in the freezer later.

Measuring Strawberries

Note: As with other fruit, the size and weight of strawberries varies; this is why some amounts are listed as ranges below.

- 1½ pounds = 1 quart or 2 pints or 4 cups
- 1 small basket = 1 pint
- 1 pint = 3¼ cups whole strawberries
- 1 pint = 1½–2¼ cups sliced strawberries
- 1 pint = 1¼–1⅔ cups pureed strawberries
- 1 cup = 4 ounces strawberries
- 1 cup = ½ cup pureed
- 1 pint = 12 large strawberries
- 1¼ cups = 10-ounce package frozen sweetened strawberries

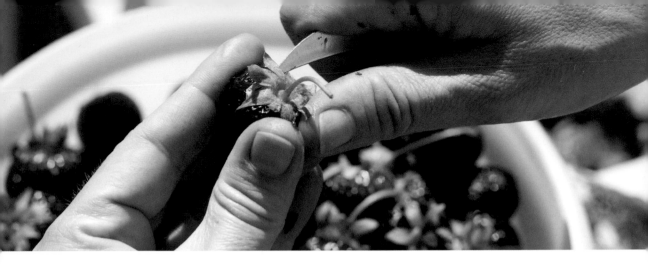

Hulling

Before consuming strawberries, most recipes require removal of the green leaves—technically known as the calyx—on top of the berry. This is known as hulling because the leaves are commonly called the hull or the cap.

There are several ways to do it:

1. Use a rigid straw and push it through the center of the berry, starting at the tip and ending by pushing the calyx off the berry. This technique works best with large, firm strawberries.

2. When hulling strawberries for yourself, you can just bite the cap off with your teeth. Alternatively, think of the calyx as nature's little handle and gather up the leaves and eat the fruit by holding it by its cap. The calyx leaves are edible but not pleasant tasting. Don't forget to compost the tops.

3. A strawberry hulling tool exists; it looks a lot like tweezers and can be purchased in specialty kitchen stores. It works, but frankly, I never think to use mine.

4. Most people use a small paring knife. I use a tourné knife (a short, curved blade that resembles a beak); this tool allows you to cut a small circle around the base of the calyx, conserving the most fruit. If the strawberry is not red all the way up, just cutting off the unripe part along with the calyx works best.

Pick-Your-Own Strawberries

Every summer, many people make it a yearly ritual to visit a local "pick-your-own" strawberry field. Since strawberries are grown in every state, there should be one near you. Across the country there are many annual strawberry festivals that often include parades, tasting contests, shows and entertainment, music, crafts, and farm games. They are great fun for kids of all ages.

Pick-your-own strawberry tips:

- Call the farm before you go for the daily strawberry update.

- Do not pick strawberries if they are wet.

- Only pick fully red and ripened strawberries.

- The cap and part of the stem should still be attached to the berry.

- Using your index finger and thumb, gently twist and pull on the stem (holding about ½ inch above the berry) to separate the fruit from the plant.

- Do not heap strawberries over 5 inches deep in your container.

Like all fresh-picked fruits and vegetables, once you taste a freshly picked strawberry, you will be spoiled by the sweetness, texture, and juiciness.

Chocolate-Covered Strawberries for All Seasons

Here are just some of the ideas I have found to decorate a chocolate-covered strawberry.

- New Year's Eve/ Wedding
- Valentine's Day
- Birthday/St. Patrick's Day
- Baby Shower
- July 4th
- Spring
- Halloween
- Football-watching party/Tailgating
- Winter Holidays

See the recipe for Basic Chocolate-Covered Strawberries on page 75 for more detailed directions.

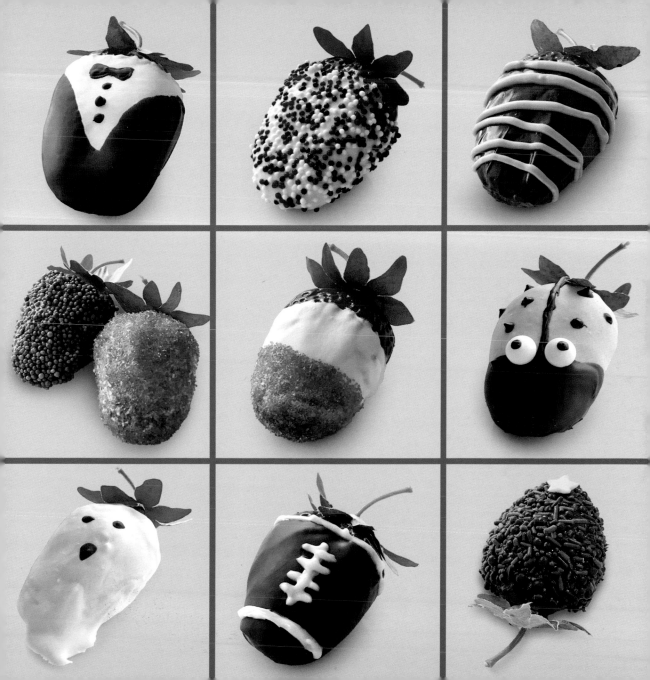

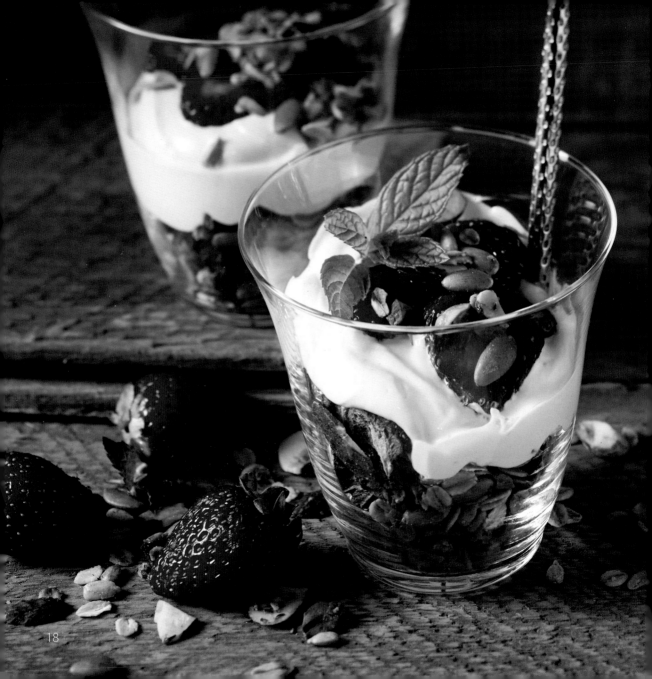

breakfast

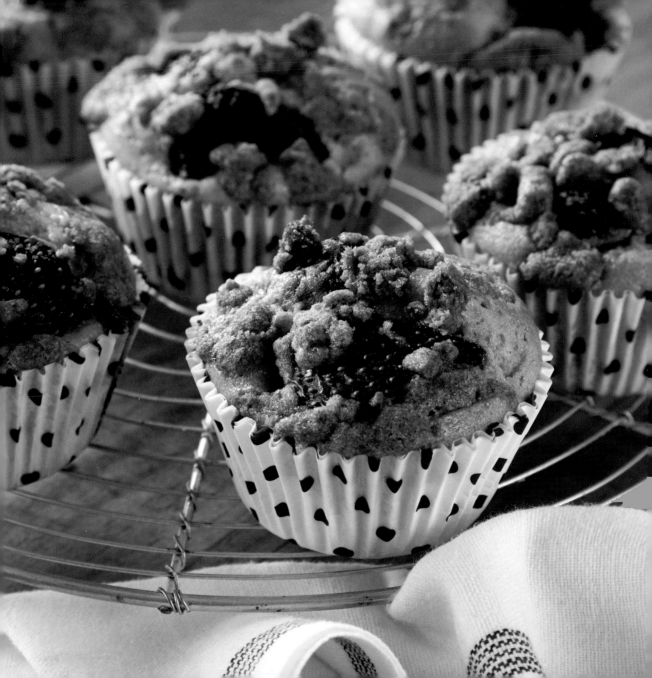

Strawberry Muffins

· ·

These pretty little muffins are a somewhat healthy but indulgent breakfast treat.

· ·

makes 18 muffins

BATTER
Vegetable cooking spray
2 cups all-purpose flour
1 cup whole wheat flour
1 cup granulated sugar
4½ teaspoons baking powder
1½ teaspoons cinnamon
¾ teaspoon salt
1 egg white
2 eggs
1 cup apple cider or apple juice
½ cup vegetable oil
2 cups sliced strawberries

TOPPING
1½ tablespoons butter
3 tablespoons all-purpose flour
3 tablespoons brown sugar
1½ teaspoons cinnamon

Preheat oven to 400°. Lightly grease 18 muffin cups with cooking spray or line with paper liners.

To make batter, combine 2 cups all-purpose flour, whole wheat flour, granulated sugar, baking powder, 1½ teaspoons cinnamon, and salt in a large bowl. In a large measuring cup, whisk together egg white, eggs, and apple cider. Slowly add oil, whisking to combine.

Make a well in center of flour mixture, and stir in egg mixture until combined. Gently stir in all but 18 strawberry slices. Spoon batter into prepared cups, filling ¾ full. Top each with 1 strawberry slice.

To make topping, stir together butter, 3 tablespoons all-purpose flour, brown sugar, and 1½ teaspoons cinnamon. Sprinkle butter mixture evenly on top of each muffin cup.

Bake for 20 to 25 minutes. Cool on a wire rack.

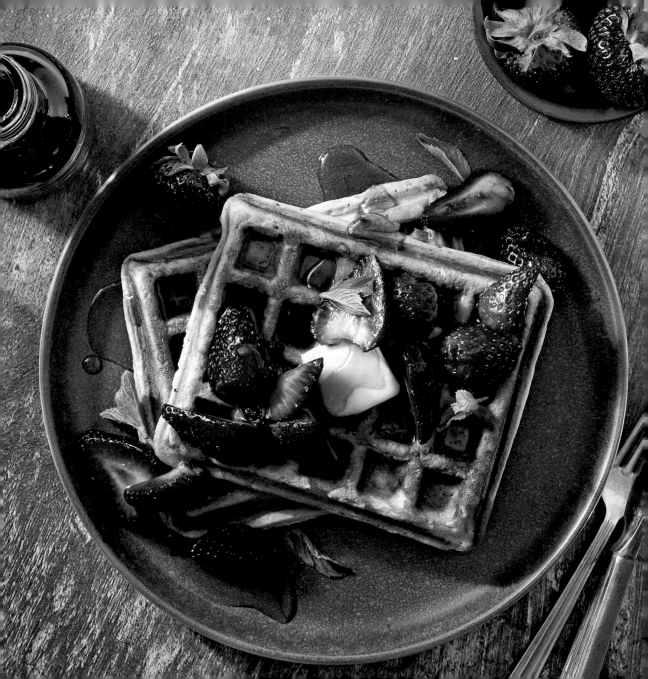

Strawberry Syrup and Waffles

••

This delicious combination is a classic for a reason!

••

makes 6 waffles

SYRUP

1 (2-pound) bag frozen sliced
　strawberries, thawed and
　undrained (about 4 cups)
½ cup maple syrup

BATTER

2 cups all-purpose flour
2 tablespoons granulated sugar
2 teaspoons baking powder
½ teaspoon baking soda
½ teaspoon salt
1½ cups buttermilk
2 eggs
⅓ cup butter, melted and cooled
1 teaspoon vanilla extract
Vegetable cooking spray
Store-bought whipped cream
　(optional)

To make syrup, combine strawberries and maple syrup in a 4-quart saucepan; bring to a simmer, reduce heat, and keep warm.

To make batter, whisk together flour, sugar, baking powder, baking soda, and salt in a large bowl. In a large measuring cup, beat together buttermilk, eggs, butter, and vanilla. Make a well in center of flour mixture; stir in buttermilk mixture to combine. Let batter rest for 10 minutes.

Heat a lightly greased (with cooking spray) waffle iron and cook according to manufacturer's instructions. (It usually takes about ½ cup batter per waffle.) Keep waffles crisp in a low-temperature oven until ready to serve. If necessary, reheat waffles on buttered waffle iron for 30 seconds. Serve warm with warm strawberry syrup and, if desired, whipped cream.

Strawberry Baked French Toast

This is a perfect dish when guests are coming for brunch,
as you put it together the night before and just bake it in the morning.
This recipe can also be made in 10 (1-cup) individual soufflé dishes.

makes 8 to 10 servings

TOAST
¾ cup butter, melted
10 cups challah (egg-twist
 bread), cut into ¾-inch cubes
 and lightly toasted
2 cups strawberries, hulled and
 cut in half
½ cup store-bought
 strawberry jam
1 (8-ounce) package cream
 cheese, cut into 30 cubes
1 cup whole milk
1 cup half-and-half
6 eggs
1 teaspoon vanilla extract
¼ teaspoon salt

TOPPING
¼ cup brown sugar
¼ teaspoon cinnamon
¼ cup maple syrup

To make toast, pour butter into bottom of a 9x13-inch baking pan. Line pan with 5 cups toasted bread cubes. Stir together strawberries and jam, and spread over bread cubes; top evenly with cream cheese cubes. Top with remaining 5 cups bread cubes.

Pour milk and half-and-half into a large measuring cup; add eggs, vanilla, and salt, and whisk to combine. Pour milk mixture over bread cubes. Flip bread pieces, if necessary, to coat sides.

To make topping, combine brown sugar and cinnamon. Sprinkle over bread mixture, then drizzle with maple syrup. Tightly cover pan with plastic wrap and refrigerate overnight.

Preheat oven to 350°. Meanwhile, bring pan to room temperature. Bake, uncovered, for 25 to 35 minutes or until puffy and golden. Serve with additional maple syrup.

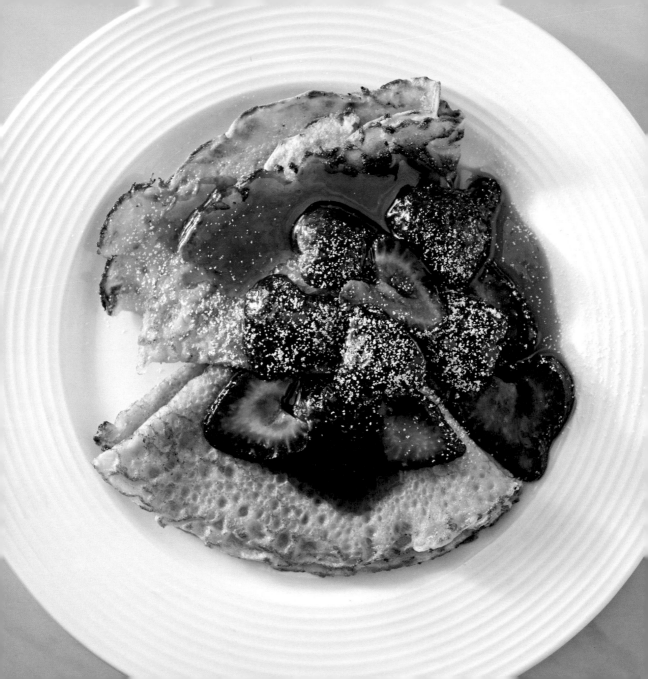

Breakfast Crepes Suzette with Strawberry Sauce

You will love this delightful combination of crepes and strawberry sauce with that classic hint of orange.

makes 8 crepes

BATTER
2 large eggs
3 tablespoons melted butter
2 tablespoons granulated sugar
1 cup all-purpose flour
1 cup milk
2 teaspoons vanilla extract
¼ teaspoon salt

SAUCE
3 tablespoons granulated sugar
3 tablespoons water
1½ tablespoons butter
⅓ cup orange juice
1 tablespoon orange liqueur
2¼ cups fresh strawberries, hulled and sliced

To make batter, combine eggs, 3 tablespoons melted butter, 2 tablespoons sugar, flour, milk, vanilla, and salt in a blender; blend until smooth. Refrigerate.

To make sauce, dissolve 3 tablespoons sugar in 3 tablespoons water in a large skillet over medium-high heat. Add 1½ tablespoons butter, and cook for 4 minutes or until golden brown. Add orange juice, stirring until smooth. Stir in orange liqueur, cooking until mixture reaches syrup consistency. Add strawberries, stirring gently to coat. Set aside.

Heat a nonstick skillet over medium-high heat. Melt a little butter and swirl to coat pan. Pour ¼ cup batter into skillet. Tilt skillet around in a circular motion to evenly coat bottom of pan in a thin layer. (Thin batter, if necessary, with ¼ cup water.) Cook for 30 seconds to 1 minute or until edges curl slightly. Flip over and cook until lightly golden.

If making ahead; slide crepes onto a plate and repeat, separating crepes with wax paper or parchment paper. To serve, fold crepes into quarters and top with warm strawberry sauce.

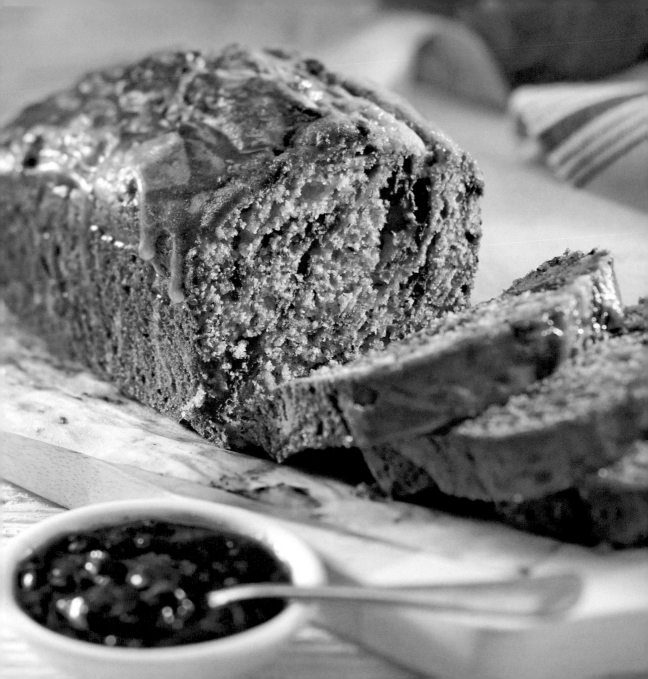

Strawberry-Banana Quick Bread

This breakfast bread is quick and cute. It's a great brunch item, and the recipe doubles easily. I just put the loaf on a cutting board with a small bread knife, and guests help themselves.

makes 3 mini loaves or 1 loaf

BATTER
Vegetable cooking spray
1 cup frozen strawberries, thawed and drained (reserving 2 tablespoons juice)
¾ cup granulated sugar
½ cup butter, softened
2 large eggs, beaten
3 ripe bananas, mashed (1 cup)
2 cups all-purpose flour
1 teaspoon baking soda
½ teaspoon salt

GLAZE
1 tablespoon butter, melted
2 tablespoons milk
1 cup powdered sugar

Preheat oven to 375°. Lightly grease 3 mini loaf pans or 1 (5x9-inch) loaf pan with cooking spray or line with parchment paper.

In the bowl of a food processor, pulse strawberries; transfer to a medium-size saucepan, and cook over medium heat, stirring occasionally, until reduced by half. Set aside to cool.

In the bowl of a stand-up mixer, cream granulated sugar and ½ cup butter until light and fluffy. Add eggs and mashed bananas; beat until combined.

In a large bowl, sift together flour, baking soda, and salt. Slowly add to banana mixture, beating slowly until just combined. Fold in cooled strawberries. Pour batter evenly into prepared pans. Bake for 15 minutes; reduce heat to 350° and bake for an additional 30 minutes or until a toothpick inserted in center comes out clean. Cool completely on a wire rack.

To make glaze, whisk together 1 tablespoon melted butter, milk, reserved 2 tablespoons strawberry juice, and powdered sugar in a small bowl. Pour over loaves, and let harden.

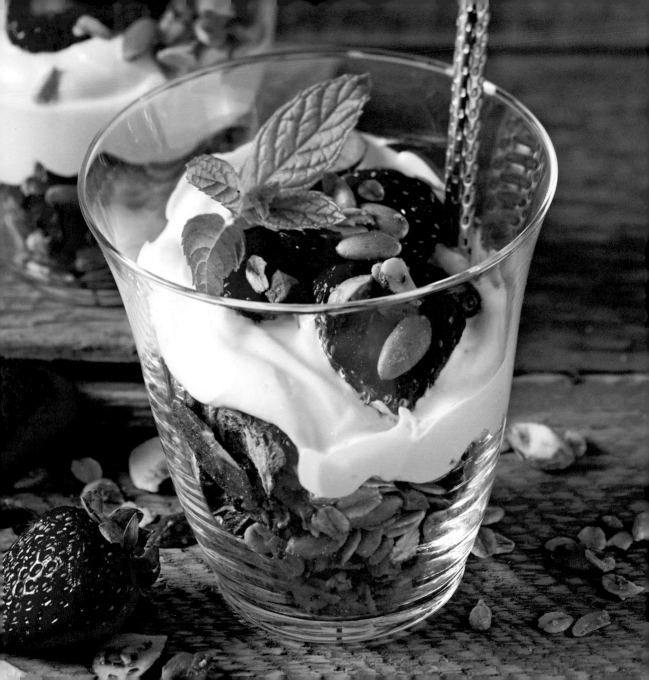

Triple Strawberry Parfaits

· ·

Strawberry yogurt, fresh strawberries, and granola with dried strawberries create a triple treat.
I taste-tested many granolas, both store-bought and homemade, and the ingredients
in this recipe are the best combination of the granolas I tried. Store this cost-effective,
healthy, and gluten-free granola in an airtight container at room temperature up to 3 weeks.

· ·

makes 9 cups granola

GRANOLA
½ cup maple syrup
½ cup coconut oil, melted
2 teaspoons vanilla extract
3 cups old-fashioned rolled oats
1 cup sliced almonds
1 cup pepitas
1 cup shelled sunflower seeds
1 cup shelled pistachios
⅓ cup ground flaxseed
½ teaspoon salt
⅛ teaspoon cinnamon
1 cup dried strawberries

PARFAITS
Strawberry yogurt
Sliced strawberries

GARNISH
Fresh mint sprigs

Preheat oven to 300°. Line 2 rimmed baking sheets with parchment paper.

To make granola, whisk together maple syrup, coconut oil, and vanilla in a large measuring cup. Toss together oats, almonds, pepitas, sunflower seeds, pistachios, flaxseed, salt, and cinnamon in a large bowl. Pour maple syrup mixture over oat mixture, and stir until completely coated. Spread onto prepared baking sheets and bake for 40 to 50 minutes, stirring every 20 minutes, until lightly brown. Remove from oven, stir in dried strawberries, and cool completely.

To make parfaits, layer desired amounts of granola, yogurt, and sliced strawberries in a glass, and top with more granola. Garnish, if desired.

beverages

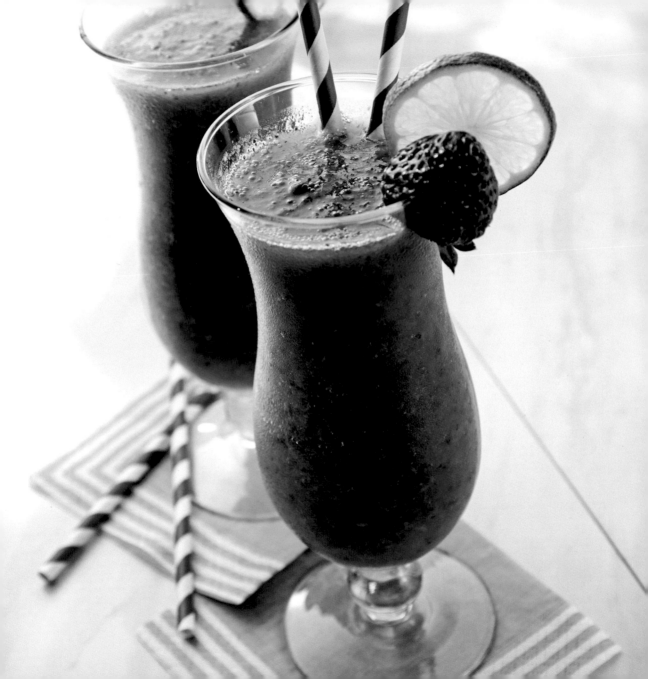

Classic Strawberry Daiquiri

• •

Take yourself on a Caribbean adventure with this drink! If you have fruit, rum, lime juice,
and triple sec, you are good to go. Start with this recipe, and then make it your own by adding other fruit,
such as peaches or bananas. Make a bigger batch by doubling the recipe.
To make a virgin daiquiri, simply leave out the alcohol.

• •

makes 2 servings

INGREDIENTS
5 fresh strawberries,
 hulled and sliced
1 cup crushed ice
2 tablespoons (1 ounce)
 lime juice
½ teaspoon powdered sugar
¼ cup (2 ounces) white rum
1 tablespoon (½ ounce)
 triple sec

GARNISHES
Whole strawberries
Lime slices

Blend sliced strawberries, ice, juice, sugar, rum, and triple sec
in a blender on high for 30 seconds. Pour strawberry mixture
into 2 martini or cocktail glasses. Garnish, if desired, and
serve with a straw or spoon.

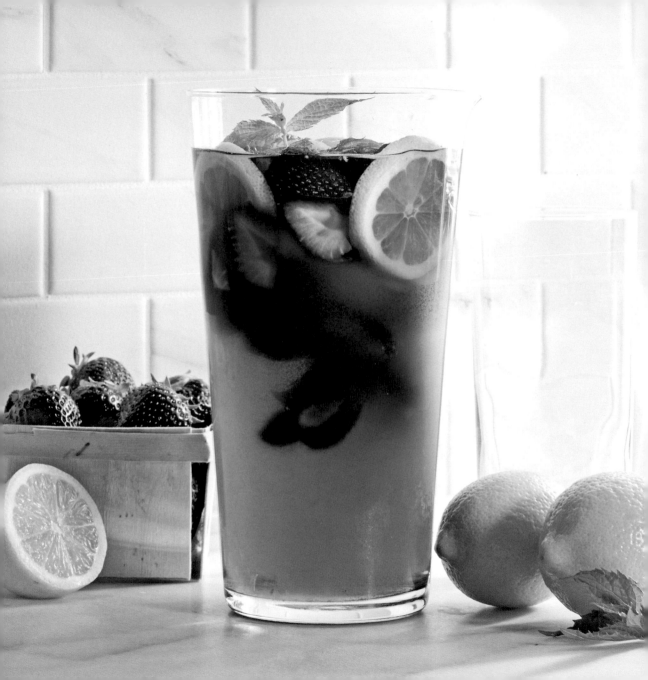

Strawberry, Mint, and Lemon Water Detox Drink

Talk about a refreshing metabolism booster! Strawberries are known to curb appetite, boost your immune system, regulate blood sugar, aid in digestion, and improve cardiovascular health. They're also packed full of Vitamin C.

makes 2 quarts

INGREDIENTS
1 lemon, thinly sliced
15 strawberries, quartered
5 mint leaves
Water

Place lemon, strawberries, and mint in a 2-quart pitcher; add enough water to fill pitcher. Stir gently with a wooden spoon to slightly bruise mint. Refrigerate overnight. (Pitcher may be refilled for a second batch.)

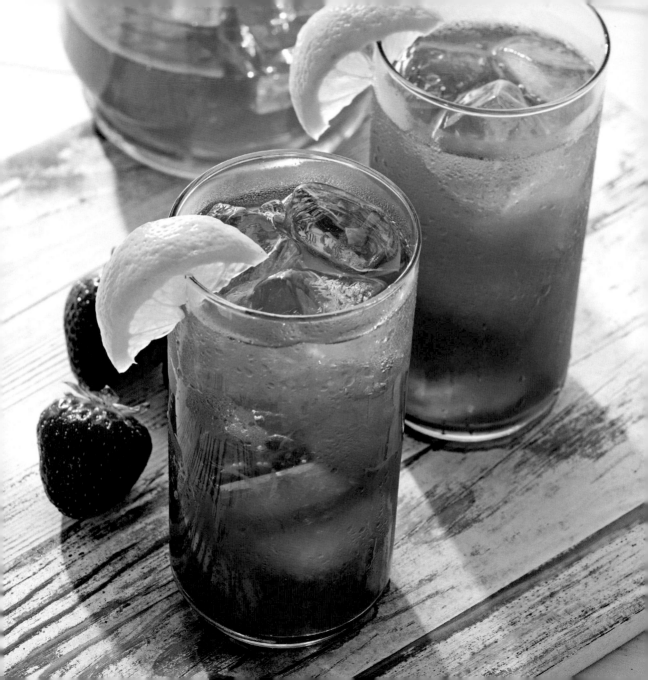

Strawberry Lemonade

· ·

Enjoy this refreshing drink on the porch with friends.

· ·

makes 1 quart

INGREDIENTS
1 cup fresh lemon juice
1½ cups strawberry juice
Water
1 cup granulated sugar
2 tablespoons light corn syrup

GARNISH
Lemon wedges

In a 1-quart pitcher, stir together lemon and strawberry juices; add enough water to fill pitcher. Stir in sugar and corn syrup until dissolved. Freeze for 45 minutes. Pour over ice cubes, and garnish, if desired.

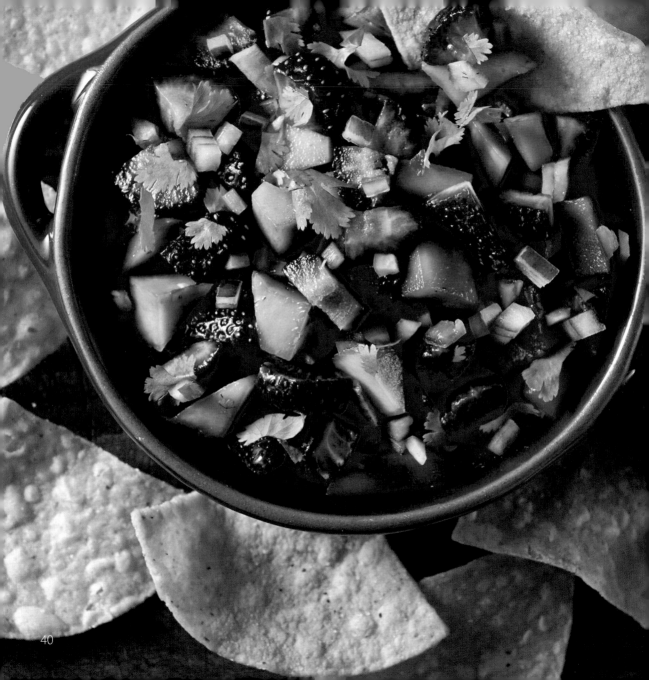

jams and sauces

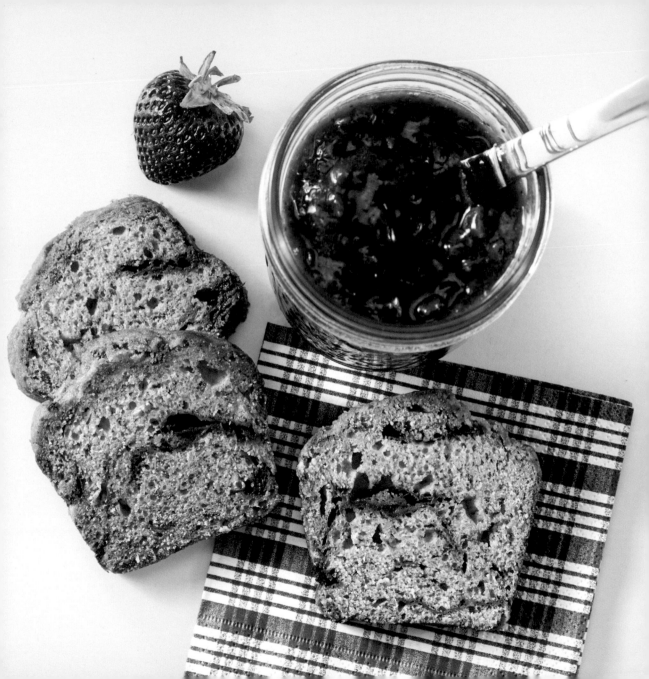

Low-Sugar Strawberry Jam

Performing an old-fashioned task like canning is so satisfying and really not that hard.

makes 4 (1-pint) jars plus 1 (4-ounce) jar

INGREDIENTS

4 (1-pint) mason jars,
 plus 1 (4-ounce) mason jar
8 cups crushed fresh (or frozen
 and thawed) strawberries*
¼ cup water
1 tablespoon lemon juice
6 tablespoons pectin
 (low or no sugar needed)
1 cup granulated sugar

Sanitize jars by boiling them in a water bath for 10 minutes. Carefully remove with canning tongs and set upright on clean paper towels; keep jars warm.

In a large stock pot, combine strawberries, ¼ cup water, and lemon juice over high heat; stir in pectin. Bring to a hard boil. Keep stirring to prevent burning. Add sugar and return to a rolling boil. Continue stirring and boiling for 1 minute; remove from heat. Skim off any foam.

Ladle strawberry mixture into prepared hot jars, filling to ¼ inch from top. Keep rims clean, and then top with new lids and rings. Place sealed jars into a boiling-water bath; boil, submerged, for 10 minutes. Remove and let cool. Once cooled, the lids should seal and you should hear a little plop. If you cannot push the center down, the lid has sealed.

*To crush strawberries, use a blender, food mill, or potato masher.

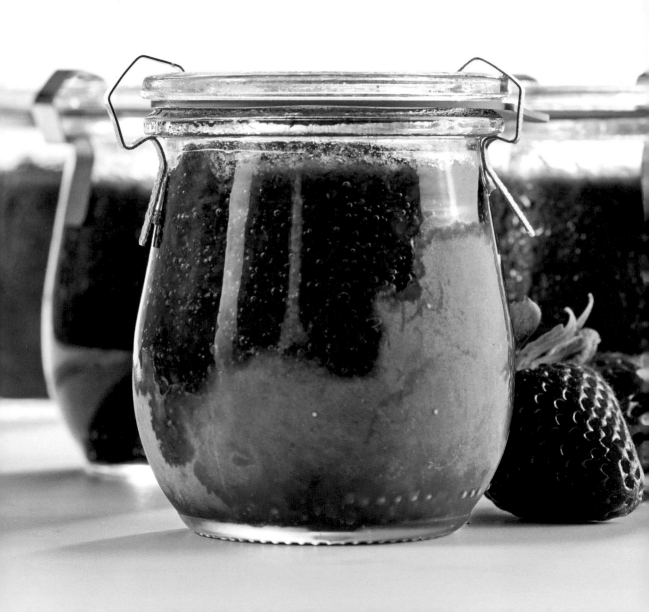

Strawberry Freezer Jam

This recipe was inspired by my friend Mara's freezer jam—with a lot less sugar!

makes 5 (8-ounce) jars

INGREDIENTS

- 5 (8-ounce) mason jars
- 5 cups frozen strawberries, thawed and undrained
- 1 tablespoon lemon juice
- ½ cup maple syrup
- ¾ cup water
- 3 teaspoons low-sugar-needed pectin (such as Pomona's Universal Pectin)
- 2 teaspoons calcium water*

Sanitize jars by boiling them in a water bath for 10 minutes. Carefully remove with canning tongs and set upright on clean paper towels; keep jars warm.

In a large bowl, mash strawberries to desired consistency. Add lemon juice and maple syrup, stirring well.

Bring ¾ cup water to a boil in a small saucepan; whisk in pectin until dissolved.

Stir pectin mixture into strawberry mixture. Add 2 teaspoons calcium water, and stir until jam mixture starts to thicken. Divide jam mixture between prepared jars, filling to ½ inch from top. Seal jars and allow to come to room temperature. Refrigerate or freeze.

*Pomona's brand pectin includes a monocalcium phosphate packet and a methoxyl citrus pectin, which allow fruit to gel without large amounts of sugar.

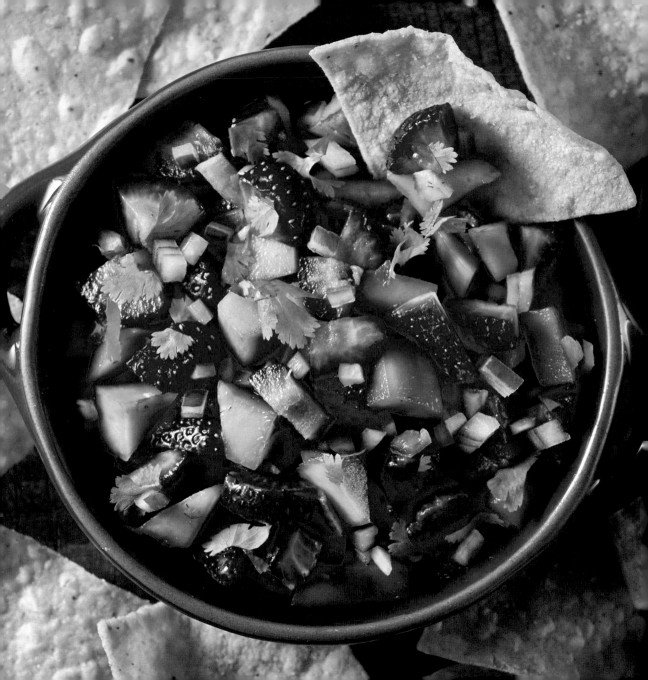

Strawberry-Mango Salsa

This colorful salsa has an interesting flavor—a combination of sweet
with a little heat from green chilis. Serve with tortilla chips or on top of fish.

makes 2 cups

INGREDIENTS
1 cup strawberries, diced
1 cup mango, diced
2 tablespoons diced red onion
2 tablespoons chopped cilantro
1 tablespoon finely chopped
 green chilis
2 teaspoons honey or
 maple syrup
¼ teaspoon salt
1 lime, juiced

In a medium-size bowl, combine strawberries, mango, onion, cilantro, chilis, honey, salt, and juice. Toss gently. Cover and store in the refrigerator for up to 4 days.

Strawberry Sauce

I encourage you to taste and adjust the sweetness of this sauce to your liking.
Fresh or unsweetened frozen strawberries can be used.
If using frozen, thaw and drain, reserving strawberry juice for another use.

makes 2 cups

INGREDIENTS
2 cups strawberries, chopped
¼–½ cup granulated sugar
2 teaspoons lemon juice

In a medium-size saucepan over medium-high heat, stir strawberries, sugar, and juice until sauce is gently boiling and sugar is dissolved. Cook for about 10 minutes or until berries are soft and sauce has thickened. Taste and adjust sugar for desired sweetness. If a smoother texture is desired, blend with an immersion blender or transfer to a blender.

Strawberry-Rhubarb Ice-cream Sauce

· ·

This sauce is delicious over vanilla or strawberry ice cream.
It can be made ahead and lasts for up to 2 weeks in the refrigerator.

· ·

makes 1½ cups

INGREDIENTS
2 cups strawberries, hulled and
 cut into halves or quarters
1 cup rhubarb,
 cut into 1-inch pieces
⅓ cup maple syrup
1 tablespoon lemon juice

Stir together strawberries, rhubarb, maple syrup, and lemon juice in a medium-size saucepan over medium heat. Simmer for 10 to 15 minutes or until tender and slightly thickened. Remove from heat to cool. Store sauce in an airtight container in the refrigerator for up to 2 weeks.

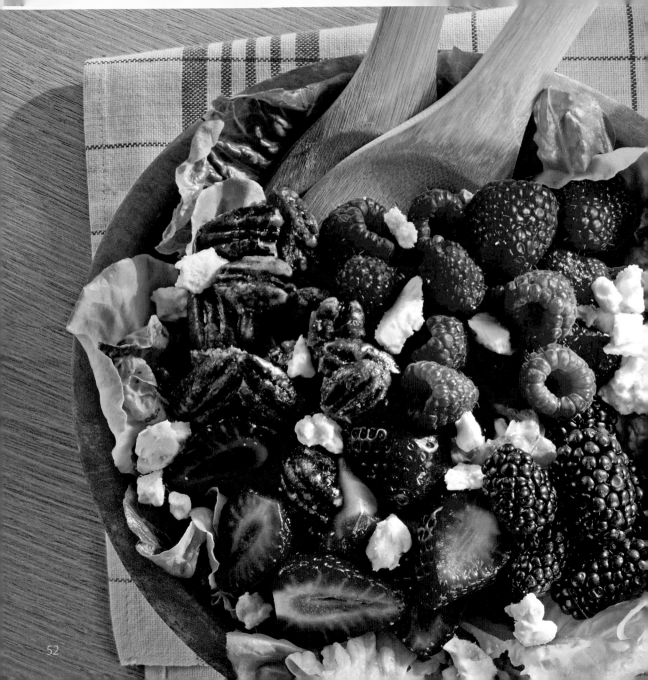

salads
and more

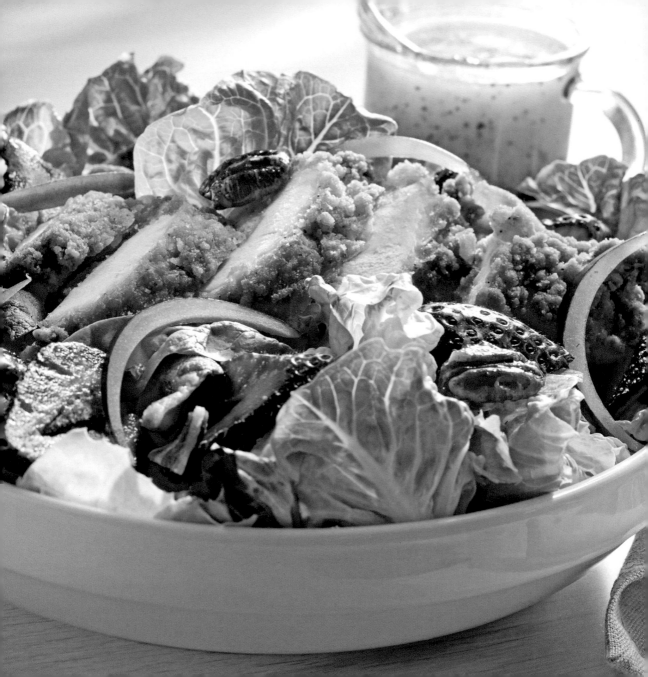

Strawberry Farms Chicken Salad with Citrus Dressing

Serve this fresh-and-tasty salad for a casual weeknight dinner.
If you're in a hurry, substitute your favorite store-bought dressing.

makes 2 servings

INGREDIENTS

8-12 ounces bacon
2 tablespoons granulated sugar
1 tablespoon water
2–3 tablespoons pecan halves
4 cups romaine, chopped
4 cups baby spinach,
 stems removed
Store-bought breaded chicken
 tenders, cooked and sliced
2–3 tablespoons thinly sliced
 red onion
1 pint fresh strawberries, sliced
Citrus Dressing (recipe at right)

Preheat oven to 350°. Line a baking sheet with aluminum foil.

Place bacon on prepared pan, and bake for 25 minutes or until crisp; drain on paper towels, and crumble into bite-size pieces. Set aside.

Add sugar and 1 tablespoon water to a small skillet over medium-high heat; bring to a boil, stirring until sugar dissolves. Add pecans and stir until mixture thickens and coats nuts. Pour onto parchment paper or aluminum foil; let cool.

In a large bowl, layer romaine and spinach. Top with bacon, chicken, red onion, strawberries, and pecans. Toss with Citrus Dressing just before serving.

Citrus Dressing: Combine ¼ **cup fresh lemon, lime,** or **orange juice; 1 teaspoon lemon, lime,** or **orange zest;** ½ **teaspoon Dijon mustard; 1 teaspoon chopped onion;** ¼ **teaspoon salt;** and **3 tablespoons maple syrup** in the bowl of a food processor. With machine running, slowly add ⅓ **cup canola oil,** and process until emulsified. Add ½ **tablespoon poppy seeds,** and pulse once.

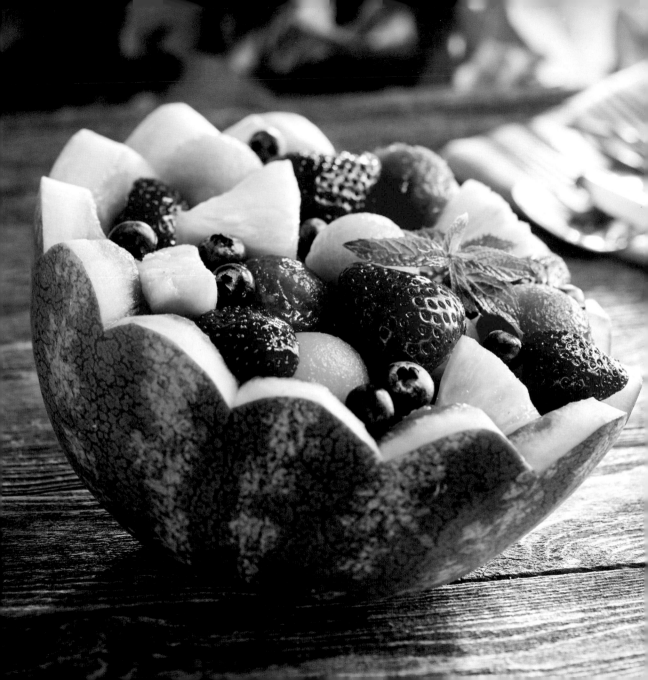

Fruit Salad in Watermelon

· ·

This beautiful fruit salad tastes as good as it looks.
Use any combination of fruit, but don't forget the strawberries!
A hollowed-out watermelon makes for a fun, retro way to serve it.

· ·

makes 12 servings

DRESSING
3 tablespoons maple syrup
1 tablespoon white vinegar
1 teaspoon ground mustard
¼ teaspoon salt
¼ teaspoon onion powder
⅓ cup canola oil
1 teaspoon poppy seeds

SALAD
1 fresh pineapple,
 cut into 1½-inch cubes
2 cups fresh strawberries,
 hulled and cut in half
1 cantaloupe,
 scooped into 1-inch balls
1 cup blueberries
1 cup watermelon,
 scooped into 1-inch balls

GARNISH
Fresh mint leaves

To make dressing, add maple syrup, vinegar, mustard, salt, and onion powder to the bowl of a food processor, and pulse to combine. With machine running, slowly add oil; process until emulsified. Add poppy seeds, and pulse once.

To make salad, combine pineapple, strawberries, cantaloupe, blueberries, and watermelon in a large bowl. Drizzle with prepared dressing, tossing gently to coat. Garnish, if desired.

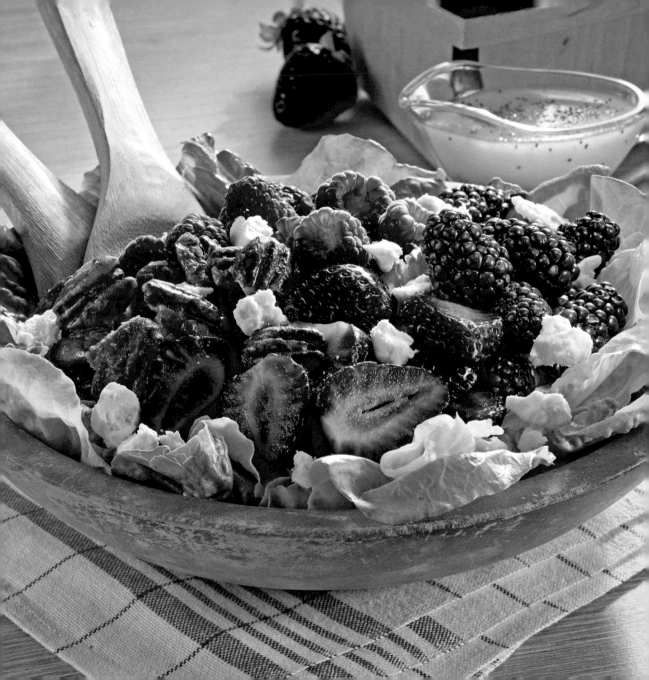

Triple Berry Salad with Candied Pecans

This beautiful salad will wow you with its great pops of flavor and color.

makes 4 to 6 servings

CANDIED PECANS
¼ cup water
½ cup brown sugar
1 cup pecan halves
Salt to taste

DRESSING
4 tablespoons fresh lemon juice
1 teaspoon lemon zest
¼ teaspoon onion powder
½ teaspoon Dijon mustard
¼ teaspoon salt
2 tablespoons maple syrup
⅓ cup vegetable oil
½ tablespoon poppy seeds

SALAD
6–8 ounces romaine or baby
 spinach (7 cups)
1 cup strawberries,
 hulled and cut in half
1 cup raspberries
1 cup blackberries
4 ounces feta cheese, crumbled

To make pecans, combine ¼ cup water and brown sugar in a medium-size saucepan over medium-high heat; bring to a boil, stirring until sugar dissolves. Add pecans and stir until mixture thickens and coats nuts. Pour onto parchment paper or aluminum foil; sprinkle with salt and let cool.

To make dressing, combine juice, zest, onion powder, mustard, ¼ teaspoon salt, and maple syrup in the bowl of a food processor; pulse until smooth. With machine running, slowly pour in oil until emulsified. Add poppy seeds, and pulse once to combine.

To make salad, layer romaine, strawberries, raspberries, and blackberries in a large serving bowl. Sprinkle with feta and pecans. Drizzle with dressing, and toss gently just before serving.

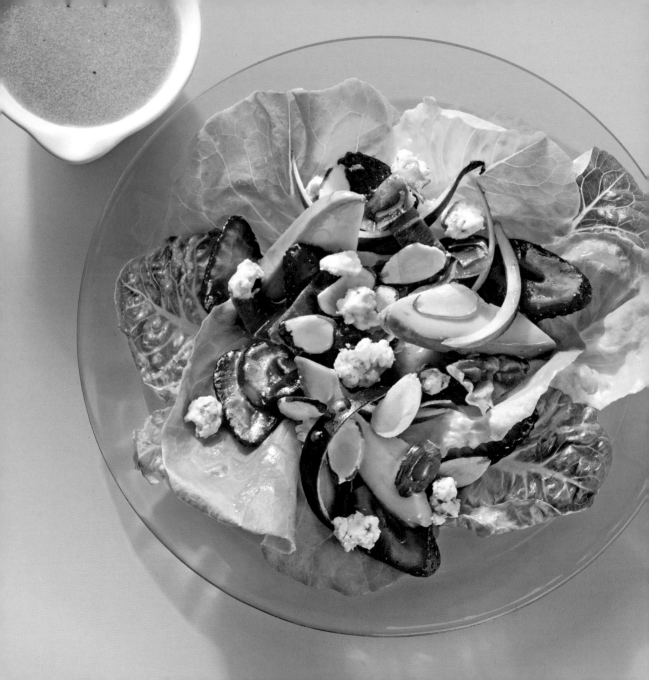

Strawberry, Avocado, and Prosciutto Salad

· ·

Expect an explosion of sweet and savory flavors with this upscale salad.

· ·

makes 4 servings

DRESSING

¾ cup strawberries, hulled
Sugar to taste (optional)
2 tablespoons lime juice
2 tablespoons unseasoned rice
 vinegar or white wine vinegar
2 teaspoons Dijon mustard
½ teaspoon salt
¼ teaspoon coarsely ground
 black pepper
⅓ cup safflower oil or mild fruity
 olive oil

SALAD

4 thin slices prosciutto
¼ cup sliced almonds
1¼ cups strawberries, hulled
 and sliced
½ small red onion, thinly sliced
6–8 cups romaine, butter
 lettuce, spinach, or watercress
1 avocado, peeled, pitted,
 and sliced
4 ounces blue cheese crumbles
 (optional)

To make dressing, place ¾ cup strawberries in the bowl of a food processor; process until smooth. Strain berries, and add sugar, if desired; return to bowl. Add juice, vinegar, mustard, salt, and pepper; pulse 4 times. With machine running, add safflower oil until emulsified.

To make salad, cook prosciutto in a large saucepan over medium heat with a little oil until crisp and slightly brown. Cool and cut into thin slices. Lightly toast almonds in pan. Layer 1¼ cups sliced strawberries and onion in the bottom of a large serving bowl; drizzle with some of the dressing. Add lettuce and avocado, tossing gently to coat and adding dressing as desired. Divide lettuce mixture between 4 salad plates. Sprinkle with prosciutto pieces, almonds, and, if desired, blue cheese.

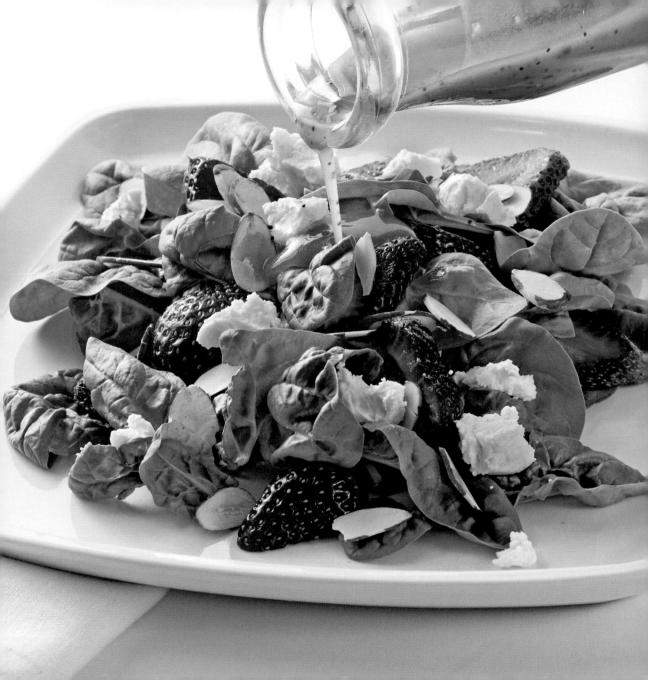

Strawberry-Almond-Goat Cheese Salad

· ·

This is my favorite go-to salad, as it's always a crowd-pleaser.
To save time, you may substitute store-bought poppy seed dressing.

· ·

makes 6 to 8 servings

DRESSING

1 cup fresh strawberries, halved
3 tablespoons red wine vinegar
1 tablespoon maple syrup
½ tablespoon Dijon mustard
½ cup canola oil
½ teaspoon salt
¼ teaspoon coarsely ground
 black pepper
1 tablespoon poppy seeds

SALAD

¼ cup sliced almonds
7–10 cups baby spinach
1 quart strawberries, sliced
4 ounces goat cheese, crumbled

To make dressing, pulse 1 cup strawberries, vinegar, maple syrup, and mustard in the bowl of a food processor until smooth and combined. With machine running, slowly add oil until emulsified. Add salt, pepper, and poppy seeds; pulse twice. Store in an airtight container in the refrigerator.

To make salad, preheat oven to 350°. Place almonds on a baking sheet and bake for 5 minutes or until lightly browned. In a large bowl, layer spinach, 1 quart strawberries, and toasted almonds. Drizzle with dressing, tossing gently to coat. Sprinkle with goat cheese.

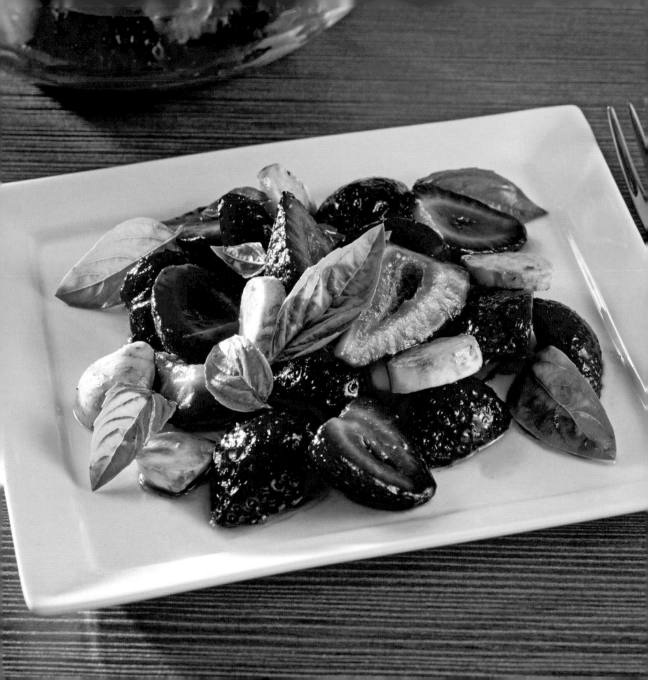

Strawberry Caprese

Everyone loves a good caprese salad, and this is the strawberry version! It's pretty, sweet, and savory. For a larger crowd, serve this caprese atop a bed of salad greens. If you're taking this dish to a party, carry the prepared ingredients in separate containers, and assemble the salad once you arrive.

makes 4 servings

INGREDIENTS

1 pound fresh strawberries, hulled and halved
4 teaspoons honey or maple syrup
¼ cup fresh basil leaves
1 cup fresh mozzarella slices
2 tablespoons extra-virgin olive oil
2 tablespoons balsamic vinegar
¼ teaspoon salt or fine sea salt
Coarsely ground black pepper to taste

In a medium-size bowl, gently combine strawberries and honey. Taste for desired sweetness. Add basil and mozzarella; drizzle with olive oil and vinegar, and gently toss to coat. Season with salt and pepper. Divide salad among 4 plates.

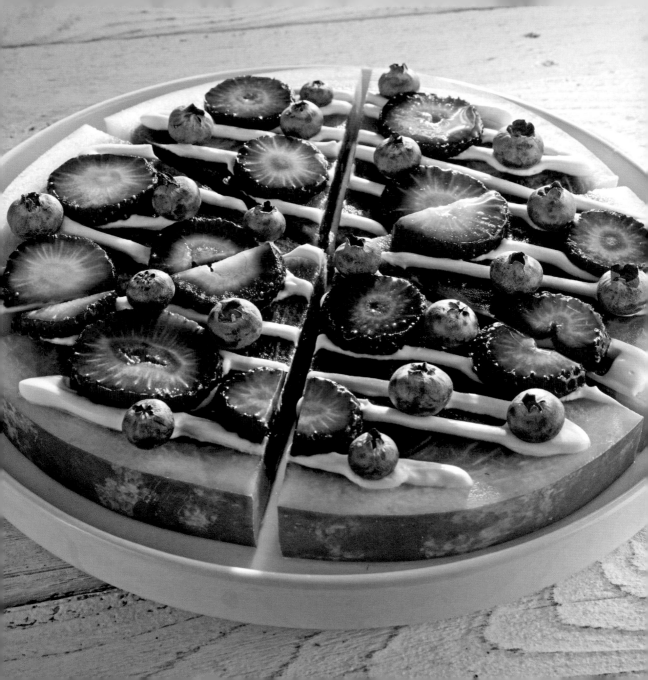

Watermelon Pizza

This beautiful and fun summer treat is easy to make.
As a bonus, it is gluten-free and very low in carbohydrates.

makes 6 servings

INGREDIENTS
1 watermelon half
3 tablespoons cream cheese, softened
3 tablespoons heavy cream
2 tablespoons powdered sugar, maple syrup, or agave nectar
4 teaspoons lemon juice
½ teaspoon vanilla extract
½ cup strawberries, sliced into circles
½ cup blueberries

Place watermelon half on a cutting board, flat side down. Cut two matching slices (about 1 inch thick). Cut each slice into 3 wedges, and then assemble them into a tight circle on a serving plate. Reserve remaining watermelon for another use.

Blend cream cheese, cream, powdered sugar, juice, and vanilla in a blender or bowl of a food processor. Transfer cream cheese mixture to a small zip-top plastic bag, and snip one corner off. Drizzle mixture onto prepared watermelon base. Top with strawberries and blueberries. Gently pull wedges out just enough to make it look like a sliced pizza. (Run a knife through cream cheese mixture, if necessary.)

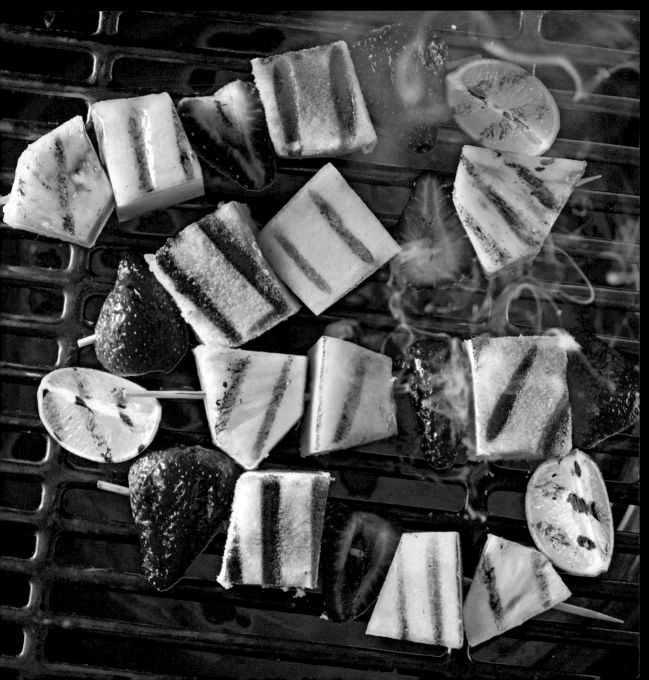

Grilled Fruit Kabobs

· ·

These summer bites are so refreshing! Grilling caramelizes
the sugar in the fruit for a little extra sweetness and flavor.

· ·

makes 6 servings

INGREDIENTS

6 wooden skewers
1 cup fresh pineapple chunks
1 cup cantaloupe chunks
1 cup large strawberries,
 stems removed and cut in half
1 cup store-bought pound cake,
 cubed
½ cup store-bought
 strawberry juice
Coconut oil spray
¼ cup dark or milk chocolate
 melting wafers (optional)

Soak wooden skewers. Assemble kabobs by threading
pineapple, cantaloupe, strawberries, and cake onto
skewers, and brush with juice.

Lightly grease heated grill grate with coconut oil spray.
Grill until fruit is slightly charred and softened.

If desired, place chocolate melting wafers in a 2-cup
microwave-safe bowl. Microwave in 30-second intervals,
stirring in between, until almost melted. (Do not overheat.)
Stir until smooth. Drizzle over warm kabobs.

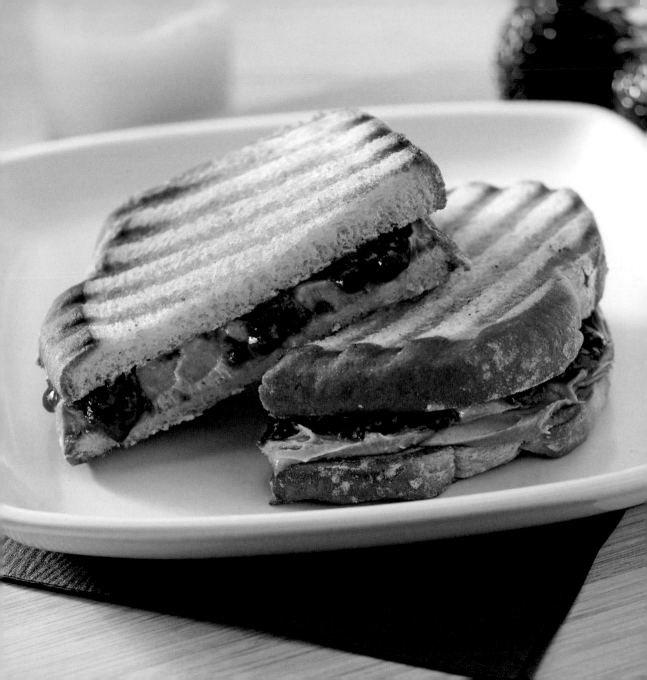

Peanut Butter-and-Strawberry Jam Panini

Use thick bread, butter, homemade jam, and your favorite peanut butter for this updated take on the classic lunch.

makes 1 serving

INGREDIENTS
2 pieces thick-sliced bread
3 tablespoons peanut butter
3 tablespoons Low-Sugar
 Strawberry Jam (page 43),
 Strawberry Freezer Jam
 (page 45), or store-bought
 strawberry jam
2 tablespoon butter, softened

Preheat panini grill pan to low.

On one bread slice, spread peanut butter; on the other slice, spread jam. Close up sandwich, and spread butter on one outer side. Place sandwich, buttered side down, onto grill pan. Butter top side of sandwich. Cook for 2 to 4 minutes or until golden brown.

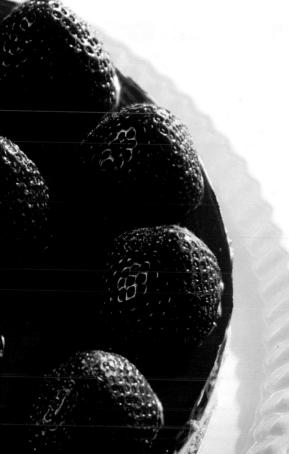

desserts

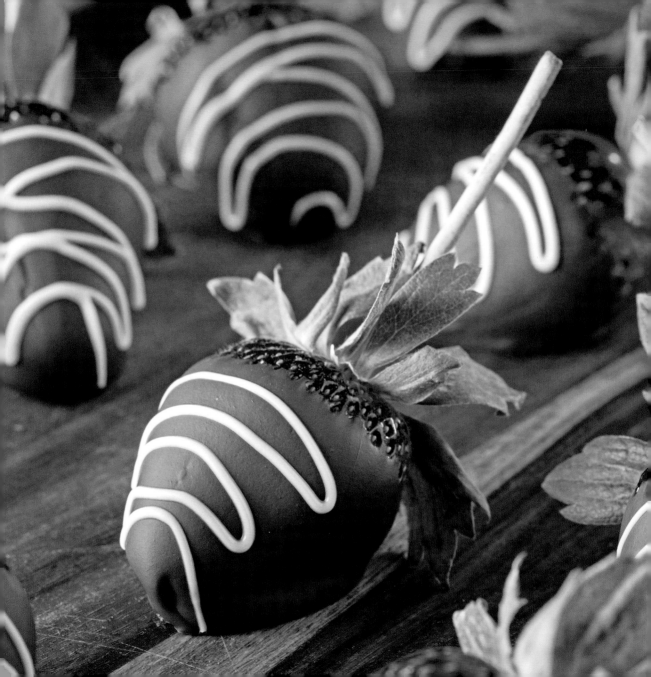

Basic Chocolate–
Covered Strawberries

· ·

These bites are always a special treat. Once you have this
technique mastered, you can apply it to all kinds of occasions.
Note: Washing the strawberries a day ahead allows them to dry completely.

· ·

makes 16 servings

INGREDIENTS

16 large strawberries, with tops
 and stems attached,
 if available
8 ounces chocolate melting
 wafers (such as Ghiradelli
 Dark Chocolate Flavored
 Melting Wafers)
4 ounces vanilla melting
 wafers (such as Ghiradelli
 White Vanilla Flavored
 Melting Wafers)

Wash strawberries gently, handling them as little as possible.
Place, stem-side down, on paper towels in a straight-sided
container. (This allows berries to dry and prevents tops from
curling.) Refrigerate, uncovered, until ready for dipping.

Line a rimmed baking sheet with parchment or wax paper.
Bring strawberries to room temperature, and make sure they
are completely dry.

Place chocolate melting wafers in a microwave-safe bowl.
Microwave in 30-second intervals, stirring in between,
until almost melted. (Do not overheat.) Stir until smooth.

Hold each strawberry gently by the stem, and dip into
chocolate, up to about ¾ of berry. Allow excess chocolate
to fall away; place on prepared baking sheet. Repeat with
remaining strawberries and chocolate, and refrigerate for
about 10 minutes or until chocolate is hardened.

Place vanilla melting wafers in a microwave-safe bowl.
Microwave in 30-second intervals, stirring in between, until
almost melted. (Do not overheat.) Stir until smooth. Transfer
to a zip-top plastic bag with one corner cut off. Drizzle over
prepared strawberries.

Patriotic Stuffed Strawberries

This no-bake, small-bite, red-white-and-blue dessert is super easy to make!

makes 24 servings

INGREDIENTS

24 large strawberries
 (about 2 pounds)
1 (8-ounce) package cream
 cheese or 1 (8-ounce)
 package whipped cream
 cheese, softened
½ cup powdered sugar
1 teaspoon vanilla extract
½ cup fresh blueberries

Place strawberries upside down on paper towels. Cut an X into each berry, from the tip down, being careful not to slice all the way through.

In the bowl of a food processor, combine cream cheese, sugar, and vanilla until light and fluffy. Fill a piping bag fitted with a star tip (or a zip-top plastic bag with one corner cut off) with cream cheese mixture. Using tip of piping bag, open up each strawberry and squeeze filling inside. Top each filled strawberry with a blueberry. Refrigerate for at least 1 hour, and store in an airtight container in the refrigerator for up to 3 days.

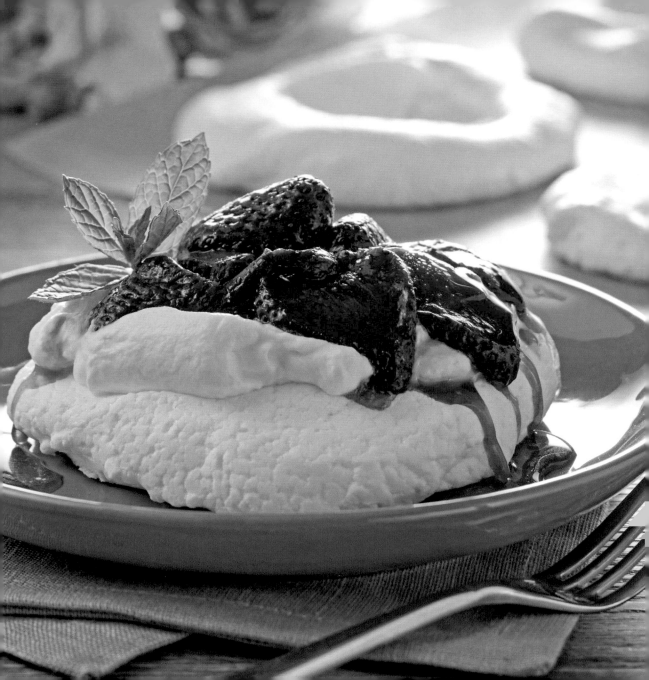

Pavlova with Strawberries and Fresh Cream

The pavlova, a little flour-free dessert cloud, is named after the famous ballerina Anna Pavlova. Meringue can be a little tricky, but it's worth the effort in this delicate dessert, made complete with fresh whipped cream and a delicious strawberry topping.

makes 9 to12 servings

INGREDIENTS

4 extra-large egg whites,
 at room temperature
1 teaspoon white wine vinegar
1 teaspoon vanilla extract,
 divided
⅛ teaspoon fine sea salt
1 cup plus 2 teaspoons superfine
 sugar, divided
2 teaspoons cornstarch
1 pound strawberries,
 hulled and sliced
1 teaspoon lemon juice
1 cup heavy whipping cream
1 tablespoon powdered sugar

GARNISH

Fresh mint sprigs

Position rack in bottom of oven and preheat to 300°. Line a large baking sheet with parchment paper. Using a pencil, draw 9 (3-inch) circles, 1½ inches apart.

In the bowl of a stand-up mixer with whisk attachment, beat egg whites, vinegar, ½ teaspoon vanilla, and salt on high speed until firm. Whisk together 1 cup sugar and cornstarch in a small bowl; add to egg white mixture, 1 tablespoon at a time, beating on high until shiny peaks form. Divide and dollop meringues into centers of circles. Using the back of a spoon, swirl mixture outward toward edge of each circle, making an indentation in the middle. Place in oven, reduce temperature to 225°, and bake for 1 hour. Turn oven off, prop oven door open, and let meringues cool for 30 minutes. Remove from oven to cool completely.

In a medium bowl, combine strawberries, remaining ½ teaspoon vanilla, lemon juice, and remaining 2 teaspoons sugar. Set aside at room temperature for up to 2 hours.

In the bowl of a stand-up mixer, whip cream until thickened. Sift in powdered sugar; whip until soft peaks form. Spoon cream onto each pavlova. Distribute berries evenly on top; drizzle with reserved juices. Garnish, if desired.

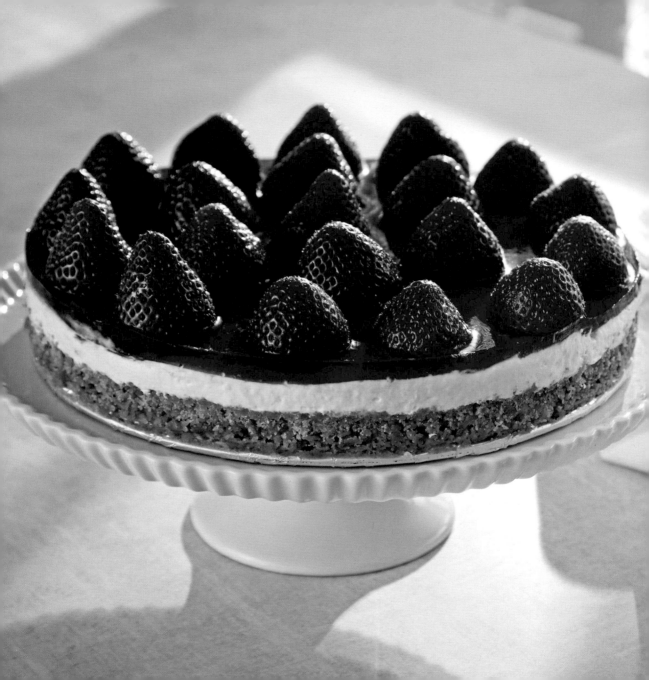

Strawberry Pretzel Dessert

This is one of those popular, quirky, retro recipes from the 1960s,
once relegated to the salad category, that I love to enjoy at least once a year.
This family favorite, now in the dessert category, is a lovely
layered dish that combines sweetness and saltiness in a terrific way.

makes 8 to 10 servings

TOPPING
1 (3-ounce) package strawberry-
 flavored gelatin mix
1 cup boiling water

CRUST
3 cups pretzels
3 tablespoons granulated sugar
¾ cup unsalted butter, melted

FILLING
1 (8-ounce) package cream
 cheese, softened
1 cup granulated sugar
1 (8-ounce) container frozen
 whipped topping (such as
 Cool Whip), thawed
12 large strawberries, stemmed

To make topping, combine gelatin mix and 1 cup boiling water in a medium-size glass bowl; stir for 2 minutes or until completely dissolved. Refrigerate until gelatin is cooled to room temperature and begins to thicken.

Preheat oven to 350°.

To make crust, process pretzels to a medium-fine crumb in the bowl of a food processor. Add 3 tablespoons sugar and melted butter; pulse until combined. Press pretzel mixture into bottom of a 9-inch springform pan. Bake for 10 minutes; set aside to cool.

To make filling, beat cream cheese and 1 cup sugar in a large bowl until smooth; gently fold in whipped topping. Spread cream cheese mixture in bottom of cooled prepared crust. Place strawberries, top sides down, evenly onto filling.

Gently spoon cooled gelatin mixture onto strawberries, and spread evenly over cream cheese mixture. Refrigerate for 4 to 6 hours or until firm. Gently release from springform pan before serving.

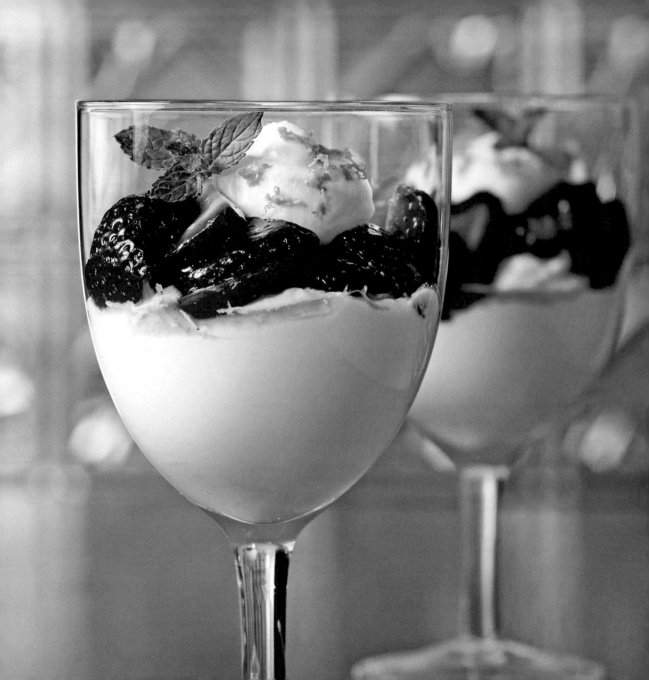

Strawberries Romanoff

• •

It is said that this dessert was first served to Russian royalty in 1820,
and Chef Antonin Careme is often credited as the inventor.
This is my somewhat simplified version of the historical strawberry dessert.

• •

makes 6 servings

INGREDIENTS

3 cups sliced fresh strawberries
2–3 tablespoons orange liqueur
 (such as Grand Marnier)
2 tablespoons granulated sugar
2 teaspoons finely grated orange
 zest, divided
¾ cup heavy cream, chilled
2 tablespoons powdered sugar

GARNISH

Fresh mint sprigs

Stir together strawberries, orange liqueur, granulated sugar, and 1 teaspoon zest in a large bowl; let stand in the refrigerator for at least 15 minutes or up to 2 hours.

Whip cream until soft peaks form; sprinkle powdered sugar on top and whip in. Reserve ½ cup whipped cream in refrigerator. Divide remaining whipped cream into 6 dessert dishes; chill for 30 minutes.

Top each chilled whipped cream serving evenly with strawberry mixture. Dollop with reserved whipped cream, sprinkle with remaining 1 teaspoon orange zest, and garnish, if desired.

Serve immediately.

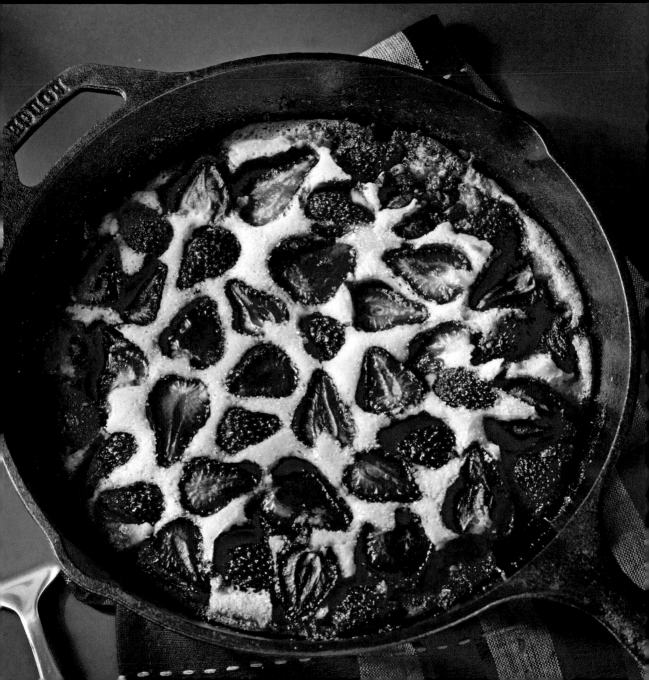

Strawberry Skillet Cobbler

Prepare this simple cobbler and pop it in the oven just before dinner is served.
Then you can enjoy the freshly baked dessert while it's warm.
It's even more delicious with a scoop of vanilla ice cream!

makes 6 to 8 servings

INGREDIENTS
⅓ cup butter
1 cup all-purpose flour
1 teaspoon baking powder
½ teaspoon salt
½ cup granulated sugar
1 cup half-and-half
1½ cups sliced strawberries
Vanilla ice cream (optional)

Preheat oven to 375°. Add butter to a 10-inch cast iron skillet; place pan in heated oven for about 5 minutes or until butter is melted.

Meanwhile, in a medium bowl, whisk together flour, baking powder, and salt until combined; add sugar, and continue to whisk until incorporated. Stir in half-and-half until just moistened. Remove pan from oven. Spread batter over melted butter; do not stir. Distribute strawberries evenly over batter, overlapping slightly.

Bake for 30 minutes or until batter has risen around fruit and edges are light brown and pulling away from pan. Serve warm with vanilla ice cream, if desired.

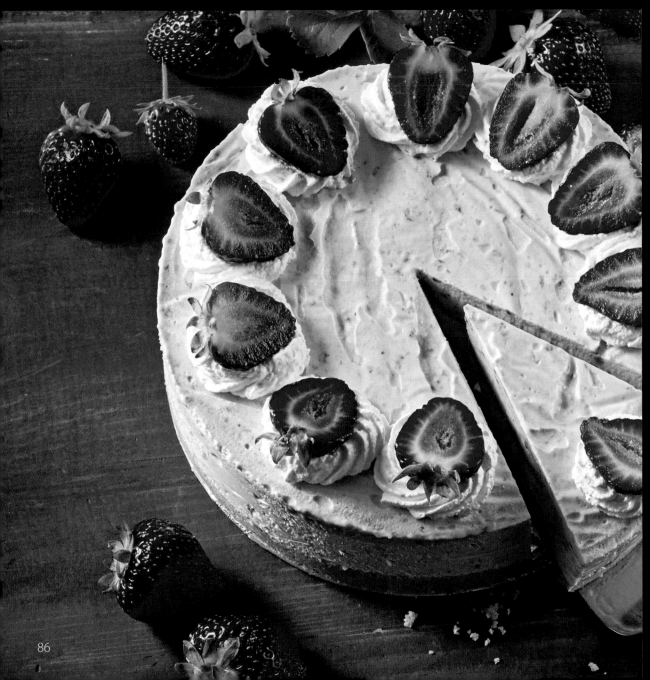

frozen treats

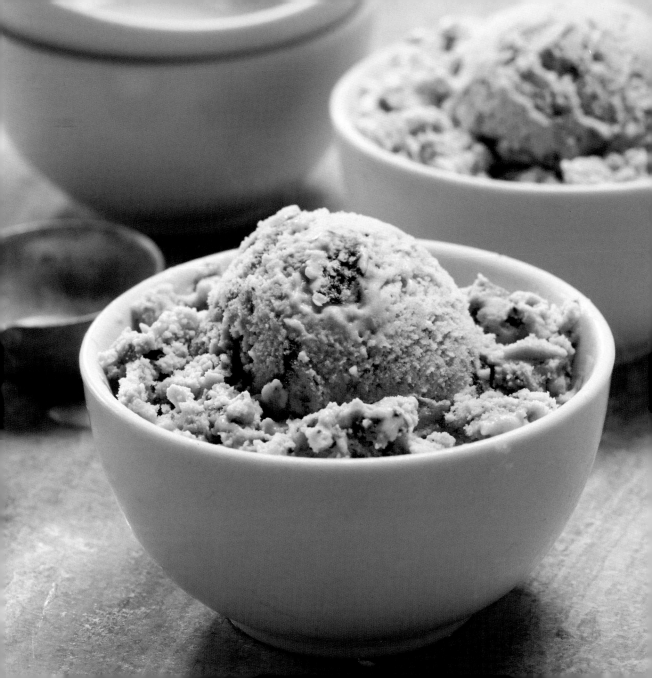

Strawberry Ice Cream

Strawberry is one of America's favorite ice-cream flavors!

makes 1½ quarts

INGREDIENTS

2 cups heavy cream
2 cups whole milk
3 vanilla beans
8 large egg yolks
1¼ cups granulated sugar,
 divided
⅛ teaspoon salt
2 cups fresh or
 frozen strawberries

In a large heavy saucepan, combine cream and milk. Split vanilla beans in half lengthwise and scrape seeds into cream mixture. Add bean pods. Bring almost to a boil and scald for 1 minute. Cover, remove from heat, and let steep for 30 minutes.

Meanwhile, whisk egg yolks in a large bowl; gradually add ¾ cup sugar and salt, whisking until thick. Gradually stir ¼ cream mixture into egg mixture. Slowly add egg mixture to saucepan. Cook over low heat (do not boil), stirring until thick enough to coat the back of a metal spoon. Remove and discard bean pods. Pour cream mixture into an airtight container, and refrigerate overnight.

In the bowl of a food processor, puree strawberries with remaining ½ cup sugar. Stir into chilled cream mixture. Freeze in an ice-cream maker according to manufacturer's directions.

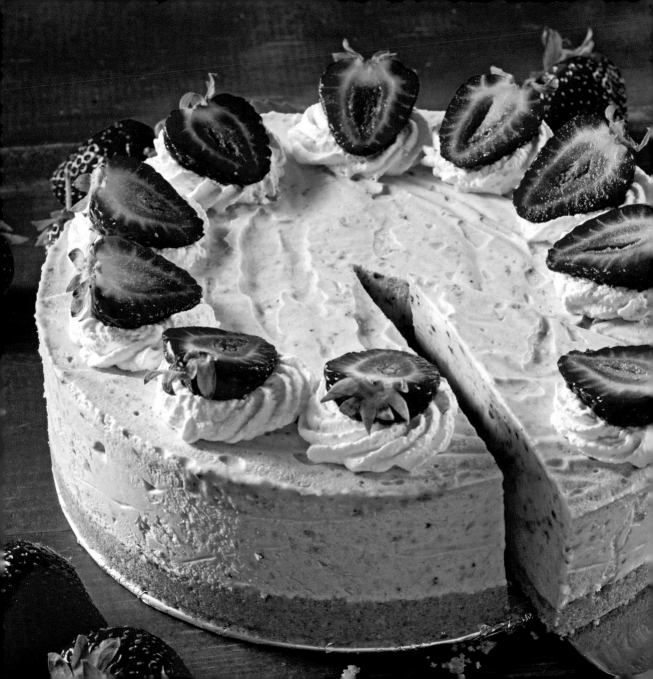

Frozen Strawberry Cheesecake

My mom used to make this in the heat of summer, and it was such a special treat.

makes 1 (9-inch) cheesecake

INGREDIENTS

1 cup crushed graham crackers
 (9 full sheets)
⅓ cup plus 1 tablespoon
 granulated sugar
3 tablespoons unsalted butter,
 melted
2 cups frozen strawberries
¼ cup orange juice
1 (8-ounce) package cream
 cheese, softened
1 cup powdered sugar
1 (8-ounce) container frozen
 whipped topping (such as
 Cool Whip), thawed

GARNISHES

Additional whipped cream
Fresh strawberries

Combine graham crackers, 1 tablespoon granulated sugar, and butter in a large bowl. Press graham cracker mixture into bottom of a 9-inch springform pan.

Blend 2 cups frozen strawberries, remaining ⅓ cup granulated sugar, and orange juice in the bowl of a food processor until smooth.

Beat cream cheese and powdered sugar in the bowl of a stand-up mixer until smooth. Fold in strawberry mixture, then whipped topping. Stir gently to combine. Pour into prepared crust, cover with plastic wrap, and freeze for 6 to 8 hours. Garnish, if desired, just before serving.

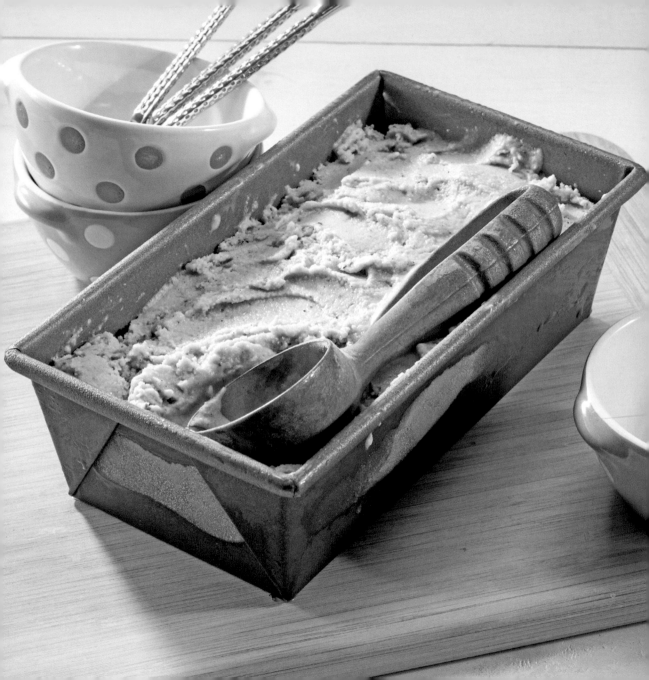

Strawberry-and-Coconut Milk Frozen Treat

This gluten-free delight has just five ingredients. When you want ice cream, but your diet restricts it, this is a great substitution.

makes 4 to 5 servings

INGREDIENTS

2 cups canned coconut milk (full fat)
⅓ cup maple syrup
⅛ teaspoon salt
1½ teaspoons vanilla extract
¾ cup strawberries, pureed

Stir together milk, maple syrup, salt, and vanilla in a large bowl. Stir in pureed strawberries. Pour strawberry mixture into 1 (8x4) metal pan, and freeze overnight.

Thaw slightly and blend in a food processor before serving. For a firmer texture, return to freezer for 1 hour.

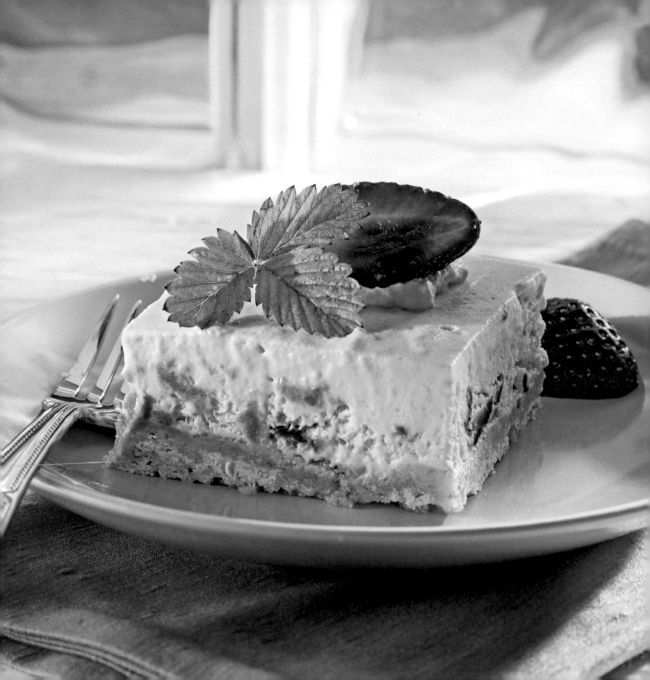

Frosty Strawberry Squares

This is one of my favorite church potluck desserts from childhood.

makes 12 servings

CRUST
1 cup sifted all-purpose flour
¼ cup brown sugar
½ cup chopped walnuts
½ cup butter, melted

TOPPING
2 egg whites
1 cup granulated sugar
2 cups fresh or frozen
 strawberries, chopped
2 tablespoons lemon juice
1 cup heavy cream

GARNISH
Fresh strawberries

Preheat oven to 350°.

To make crust, combine flour, brown sugar, walnuts, and butter in a large bowl; press flour mixture into a 9x13-inch baking pan and bake for 20 minutes. Cool.

To make topping, beat egg whites, granulated sugar, strawberries, and lemon juice in the bowl of a stand-up mixer on high for about 10 minutes or until soft peaks form. In a separate bowl, whip cream until soft peaks form; fold into strawberry mixture. Spoon over prepared crust and smooth with a spatula. Freeze for 6 hours or overnight. Cut into squares, and garnish, if desired.

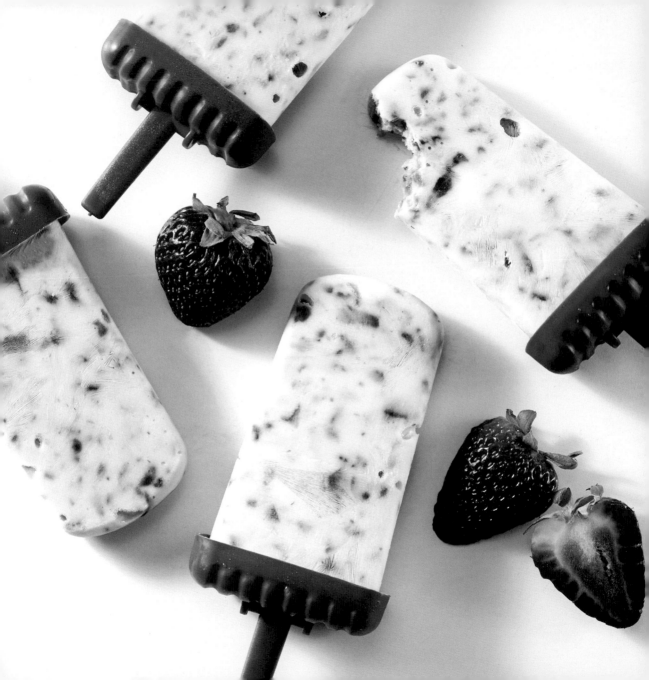

Strawberry Yogurt Pops

• •

With just two healthy ingredients, you can whip these up on a hot afternoon in no time.

• •

makes 6 servings

INGREDIENTS

1 pound fresh or frozen
 strawberries, hulled
1½ cups vanilla-flavored
 Greek yogurt

Process strawberries in the bowl of a food processor until only small pieces remain. Add yogurt, stirring gently to combine. Using a small ladle, transfer strawberry mixture to ice-pop molds, and freeze until completely solid. To remove from molds, use the heat of your hands to slightly melt the outside and then tug gently.

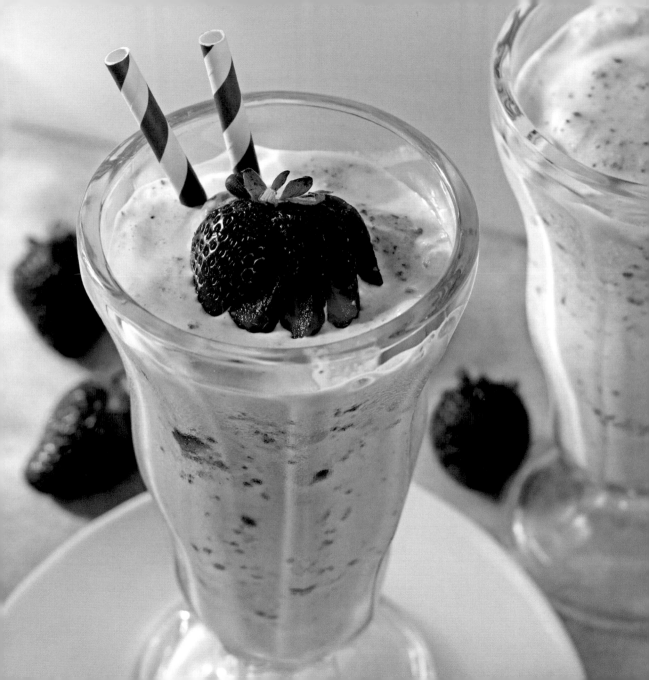

Strawberry Milkshakes

··

These are such a simple thing to make—and they're simply good.

··

makes 2 (1-cup) servings

INGREDIENTS
¾ cup frozen strawberries
⅓ cup whole milk
2 cups vanilla ice cream

GARNISH
Whole strawberries

Blend strawberries and milk in a blender until combined; add ice cream. Blend to desired consistency. Garnish, if desired.

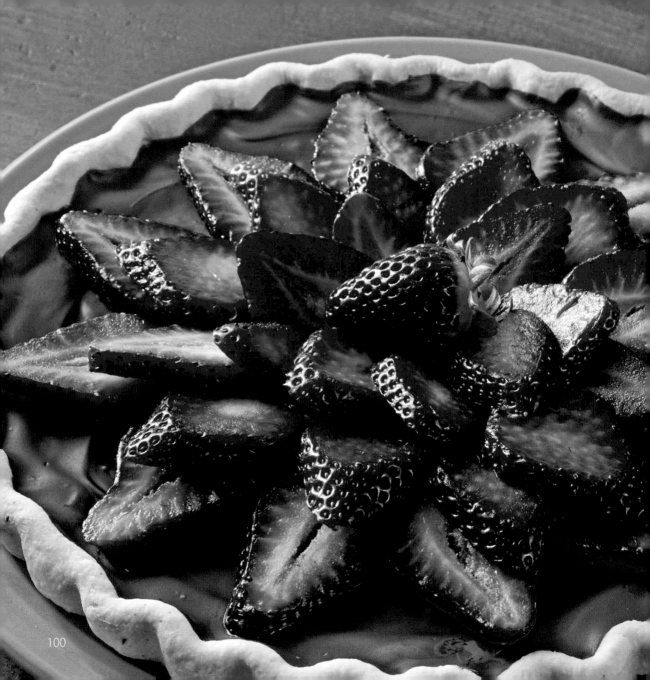

pies and tarts

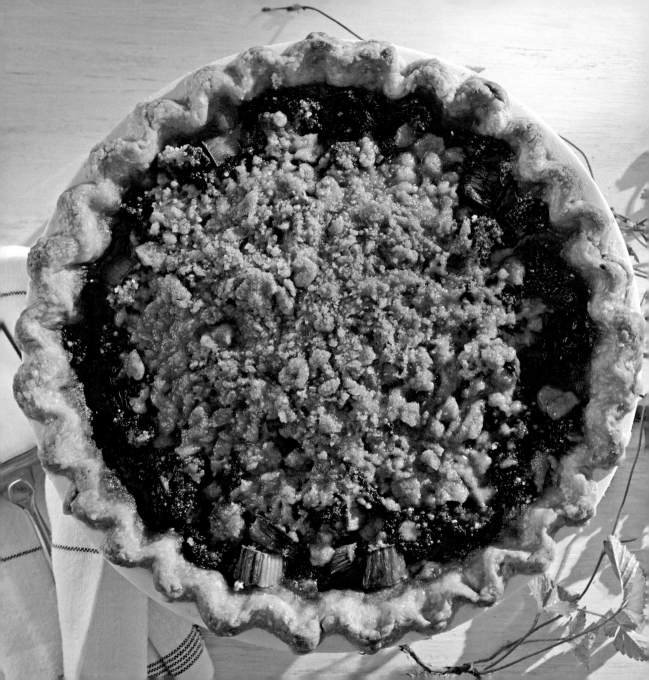

Strawberry-Rhubarb Streusel Pie

The season is short for both rhubarb and locally grown strawberries,
and spring just does not feel right until I have made this pie.
The flour-sugar combination on the bottom prevents a soggy crust.

makes 1 (9-inch) pie

STREUSEL
½ cup all-purpose flour
⅓ cup light brown sugar
½ teaspoon cinnamon
2 tablespoons butter

PIE
1 store-bought
 refrigerated piecrust
1 cup granulated sugar, divided
1 tablespoon all-purpose flour
3 cups strawberries
2 cups rhubarb
3 tablespoons instant tapioca
 or arrowroot
1 tablespoon grated orange zest
2 tablespoons fresh orange juice
2 teaspoons vanilla extract
¼ teaspoon salt
¼ teaspoon cinnamon
Vanilla ice cream (optional)

To make streusel, place ½ cup flour, brown sugar, ½ teaspoon cinnamon, and butter in the bowl of a food processor with a metal blade; pulse until crumbly. Set aside.

Preheat oven to 400°. Roll piecrust into an 11-inch circle; place in a 9-inch pie plate, and flute edges. Combine ¼ cup sugar with 1 tablespoon flour, and sprinkle evenly on bottom of crust. Chill in freezer.

Meanwhile, combine strawberries, rhubarb, remaining ¾ cup sugar, tapioca, zest, juice, vanilla, salt, and ¼ teaspoon cinnamon. Spoon strawberry mixture into prepared crust. Bake for 30 minutes.

Remove pie from oven and sprinkle evenly with streusel. Reduce oven temperature to 350° and bake for 25 minutes, shielding crust with aluminum foil, if necessary, to prevent excessive browning. Cool slightly. Serve warm or at room temperature with vanilla ice cream, if desired.

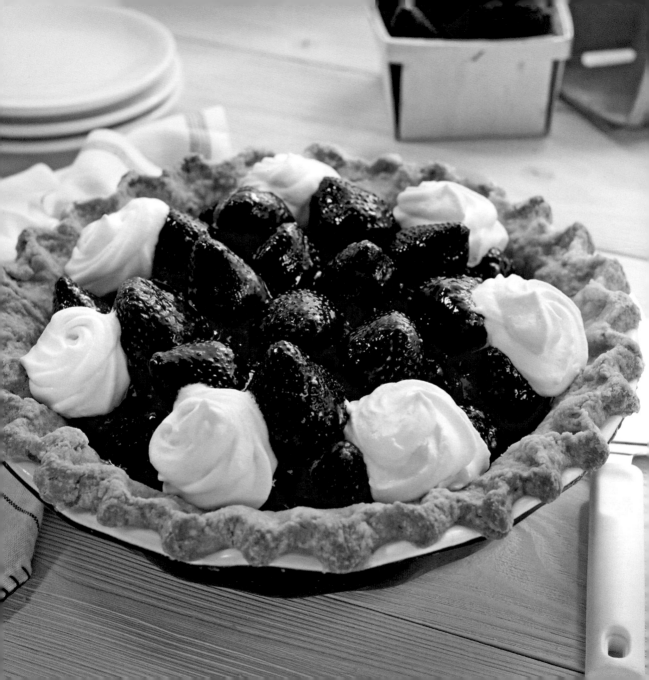

Fresh Strawberry Pie

· ·

This beautiful strawberry pie says summer! Make it when
you have 8 cups of ripe strawberries that are plump but firm.

· ·

makes 1 (9-inch) pie

INGREDIENTS

8 cups fresh strawberries,
 hulled and divided
¾ cup granulated sugar
3 tablespoons cornstarch
½ cup water
1 store-bought
 refrigerated piecrust
1 cup heavy cream
2 tablespoons powdered sugar
½ teaspoon vanilla extract

Puree 1 cup strawberries in the bowl of a food processor; transfer to a medium-size saucepan, and bring to a boil over medium heat, stirring constantly, for 3 minutes or until thick and translucent. Whisk together granulated sugar and cornstarch in a small bowl; add to strawberry puree. Stir in ½ cup water, and cook, stirring constantly, until strawberry mixture returns to a boil and thickens. Set aside to cool completely.

Preheat oven to 375°.

Roll out piecrust dough; fit into a 9-inch pie plate and crimp edges. Line with aluminum foil and fill with pie weights or dried beans; bake for 20 to 25 minutes. Remove foil and weights, and bake an additional 10 to 15 minutes or until crust is a deep golden brown.

Place remaining 7 cups strawberries in prepared crust. (Cut any extra-large strawberries in half; place cut sides down in crust.) Gently spoon strawberry puree mixture over berries. Chill for 2 hours.

Whip cream until soft peaks form; add powdered sugar and vanilla, stirring to combine. Continue to whip until firm peaks form. Pipe onto chilled pie just before serving.

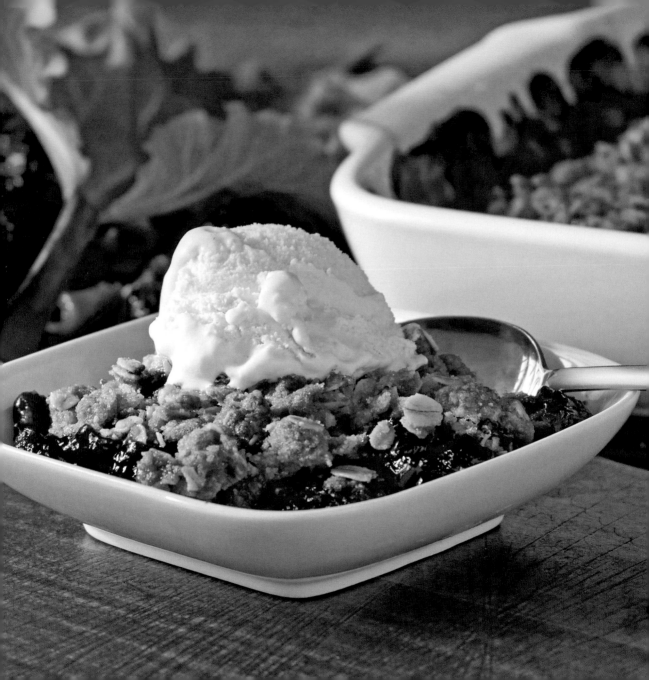

Quick Strawberry-Rhubarb Crisp

Peanut butter and jelly, bacon and eggs, strawberries and rhubarb…
some foods just pair together naturally. This quick crisp celebrating the marriage of
strawberries and rhubarb tastes great the next morning as well. Dessert for breakfast, anyone?

makes 6 servings

INGREDIENTS

3 cups strawberries, quartered
2 cups rhubarb,
 cut into ½-inch pieces
1 cup plus 2 tablespoons
 all-purpose flour, divided
½ cup granulated sugar
1 teaspoon cinnamon
¾ cup brown sugar,
 tightly packed
¾ cup old-fashioned oats
1 pinch of salt
½ cup unsalted butter, melted
Vanilla ice cream (optional)

Preheat oven to 350°.

Combine strawberries, rhubarb, 2 tablespoons flour, and granulated sugar in an ungreased 9x9-inch baking pan.

In a medium bowl, combine remaining 1 cup flour, cinnamon, brown sugar, oats, and salt. Stir in melted butter until combined and crumbly. Sprinkle mixture over fruit. Bake for 45 minutes. Serve warm with vanilla ice cream, if desired.

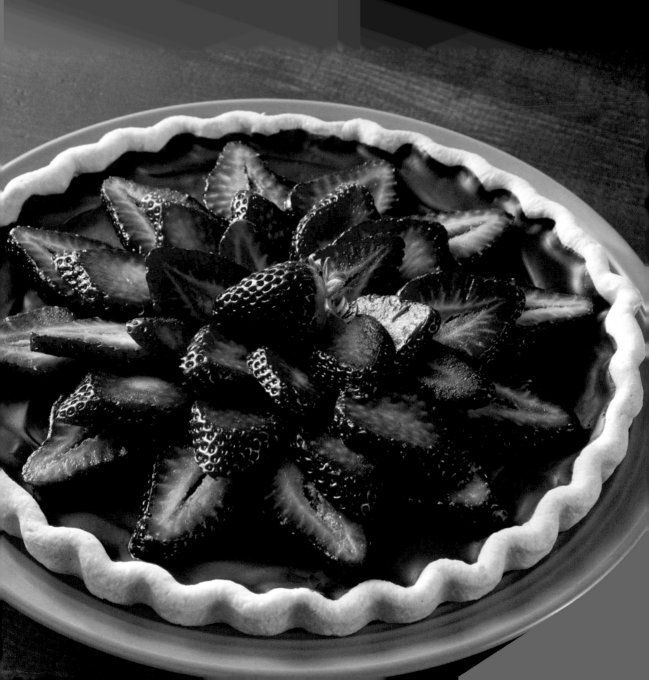

Strawberry Chocolate Tart

• •

The classic combination of strawberries and chocolate comes together quickly in this beautiful five-ingredient tart.

• •

makes 8 servings

INGREDIENTS
1 store-bought
 refrigerated piecrust
3 ounces chocolate (semisweet
 or dark), coarsely chopped
1 quart strawberries, cut
 lengthwise into ¼-inch-thick
 slices and reserving 1 whole
 strawberry
½ cup store-bought seedless
 strawberry jelly

Preheat oven to 400°. Fit piecrust into a 9-inch tart pan; prick bottom of crust several times with a fork. Bake for 15 minutes or until edges are lightly brown; cool.

Place chocolate in a microwave-safe bowl, and microwave at 30-second intervals, stirring in between, until melted. Brush chocolate inside bottom of prepared crust, and cool in the refrigerator.

Starting on the outside, place largest strawberry slices evenly around bottom of crust. Repeat rows, slightly overlapping edges. Place 1 whole strawberry in center.

Place jelly in a microwave-safe bowl, and microwave until it becomes liquid. Brush melted jelly over strawberry slices. Refrigerate until cold.

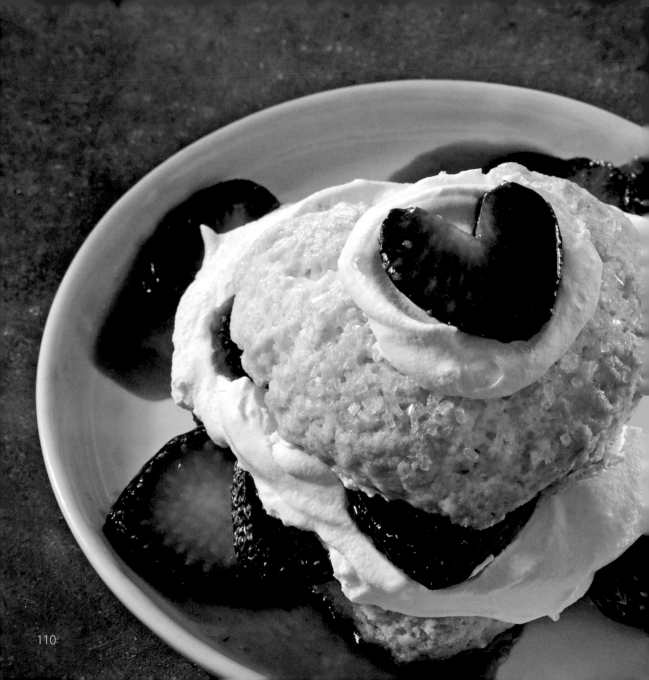

cakes, cookies, bars

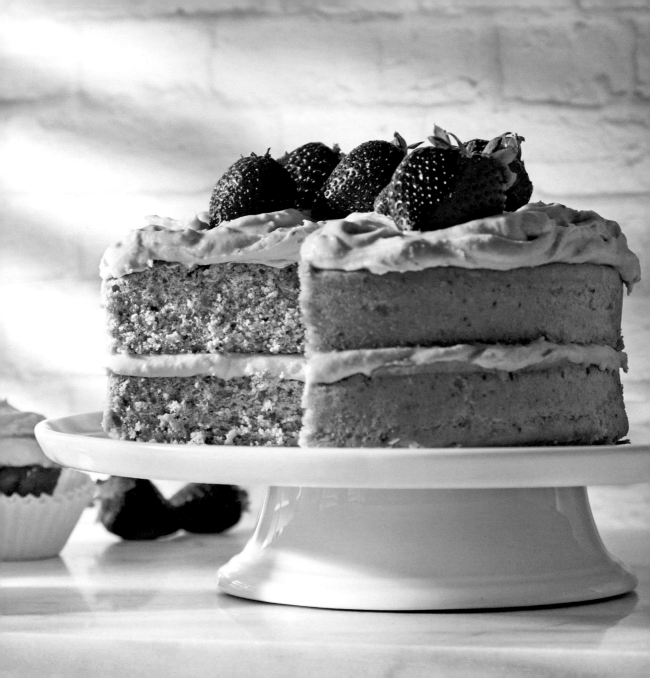

Strawberry Cake with Strawberry–Cream Cheese Frosting

This pretty cake has much less sugar than most, plus it is pink, moist, and has a fresh strawberry flavor. For a pinker cake or frosting, add a few drops of red food coloring.

makes 1 (2-layer) cake or 24 cupcakes

CAKE
Vegetable cooking spray
All-purpose flour
1 package white cake mix
1½ cups frozen strawberries, thawed and pureed
½ cup sweetened applesauce
2 large eggs

FROSTING
1 (8-ounce) package cream cheese, at room temperature
8 tablespoons butter, at room temperature
3½ cups powdered sugar, sifted
¾ cup fresh strawberries, chopped and mashed to make ½ cup

GARNISH
Whole strawberries

To make cake, move rack to center of oven. Preheat oven to 350°. Lightly grease 2 (8-inch) round cake pans with cooking spray and lightly dust with flour.

In the bowl of a stand-up mixer, combine cake mix, pureed strawberries, applesauce, and eggs; beat on low speed for 1 minute. Scrape sides of bowl. Beat on medium speed for 2 minutes or until completely combined. Pour batter evenly into prepared pans, and smooth tops. Bake for 30 to 35 minutes or until lightly brown and a toothpick inserted in center comes out clean. Cool on a wire rack for 20 minutes.

Meanwhile, to make frosting, mix cream cheese and butter in the bowl of a stand-up mixer until smooth. Add sugar and mashed strawberries. Blend on low until sugar is incorporated. Beat for 2 minutes on medium-high until light and fluffy. Frost cooled cake. Garnish, if desired.

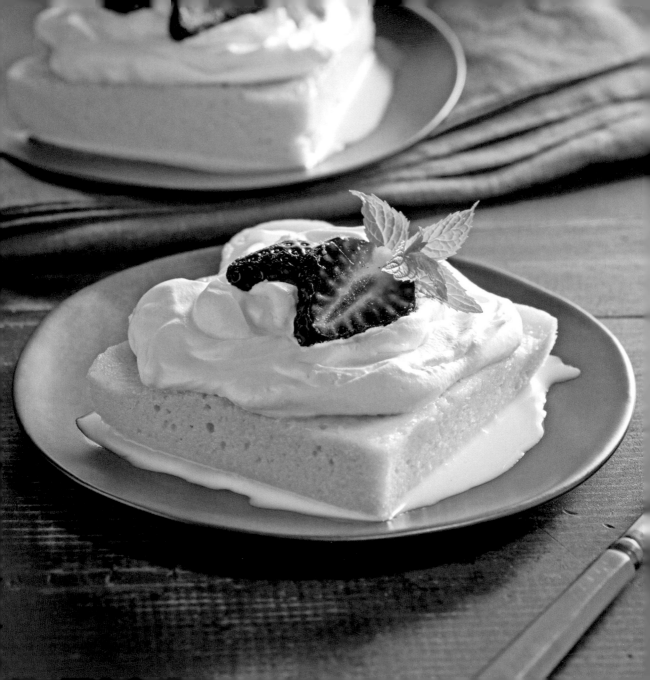

Strawberry Tres Leches Cake

My friend Karen inspired this version of the popular Latin American cake with a twist on the classic combination of strawberries and cream. This dessert should be made ahead and cooled overnight so that all three of the milks soak into the cake.

makes 12 servings

INGREDIENTS
1½ cups all-purpose flour
2 teaspoons baking powder
½ teaspoon salt
¼ cup butter, softened
5 eggs or 3 extra-large eggs
¾ cup granulated sugar
2 teaspoons vanilla extract
1 (14-ounce) can sweetened
 condensed milk
1 (12-ounce) can
 evaporated milk
2 cups heavy cream, divided
7 cups sliced strawberries
Granulated sugar to taste

GARNISH
Fresh mint sprigs

Preheat oven to 350°. Butter a 9x13-inch baking pan.

Combine flour, baking powder, and salt in a large bowl. In the bowl of a stand-up mixer, beat butter, eggs, sugar, and vanilla on high for 5 minutes or until egg mixture is light and fluffy. Slowly and gradually add flour mixture to egg mixture, beating to combine. Pour batter into prepared pan and bake for 20 to 30 minutes or until a toothpick inserted in center comes out clean.

In a large measuring cup, combine condensed milk, evaporated milk, and ½ cup cream. Poke top of warm cake with a skewer and pour milk mixture all over the top. Let sit for 15 minutes. Cover with plastic wrap and refrigerate for 4 hours or overnight.

Sprinkle sliced strawberries with sugar to taste. Whip remaining 1½ cups cream with sugar to taste. Serve berries and whipped cream with cake. Garnish, if desired.

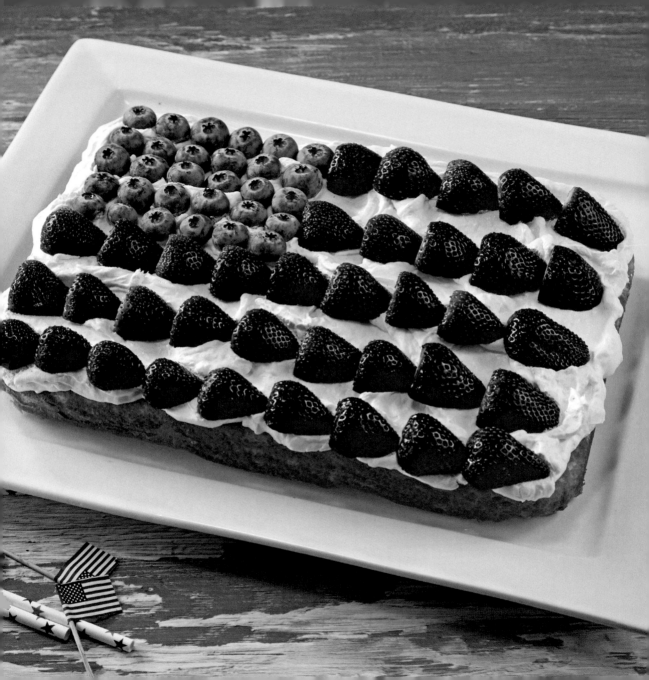

American Flag Cake

Bring this to a summer cookout! It should be fine at room temperature for up to 2 hours; if it is above 90° and the party is outside, however, only leave it out for 1 hour.

makes 16 servings

INGREDIENTS

1 package white or yellow cake mix

1 (16-ounce) container frozen whipped topping (such as Cool Whip), thawed

1 pint blueberries

2 pounds strawberries, halved

Preheat oven to 350°. Line a 9x13-inch baking pan with aluminum foil.

Prepare cake mix according to package directions. Cool completely, and transfer to a platter to peel off foil. Frost with whipped topping.

Dry blueberries and cut sides of strawberries on paper towels. Arrange blueberries in rows in the top, left corner to represent stars, and arrange strawberries to represent stripes. Refrigerate until ready to serve.

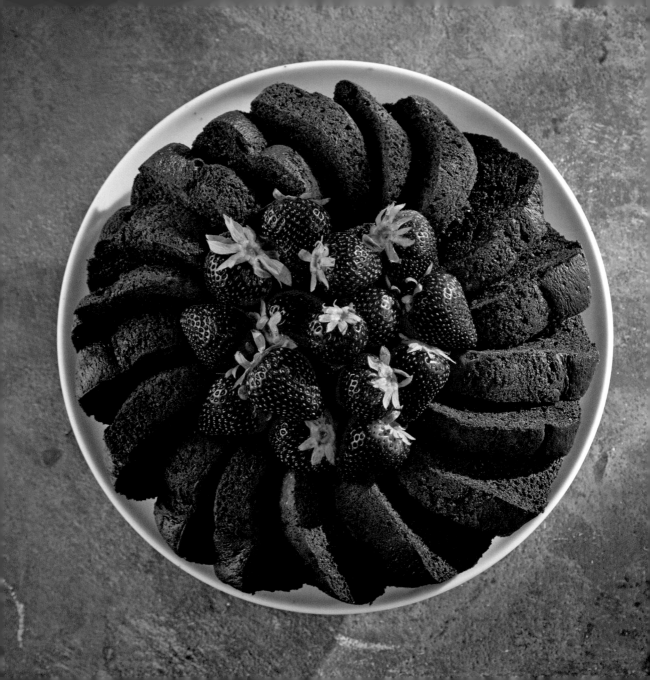

Chocolate Bundt Cake with Strawberries

Satisfy your sweet tooth with a generous slice of this delicious chocolate cake!

makes 12 servings

INGREDIENTS
Vegetable cooking spray
1 package dark chocolate
 cake mix
1 package instant chocolate
 pudding mix
4 large eggs, at room temperature
1 cup sour cream
¾ cup canola oil
¾ cup brewed coffee
¼ cup granulated sugar
1–2 pints strawberries, with tops
 and stems attached,
 if available

Preheat oven to 350°. Lightly grease a 10-inch Bundt pan or fluted tube pan with cooking spray.

In the bowl of a stand-up mixer, combine cake mix, pudding mix, eggs, sour cream, oil, coffee, and sugar. Beat on low speed for 30 seconds, then beat on medium speed for 2 minutes. Pour batter into prepared pan. Bake for 50 to 55 minutes or until a wooden pick inserted in center comes out clean. Cool for 10 minutes; remove from pan and cool completely on a wire rack. Top with strawberries.

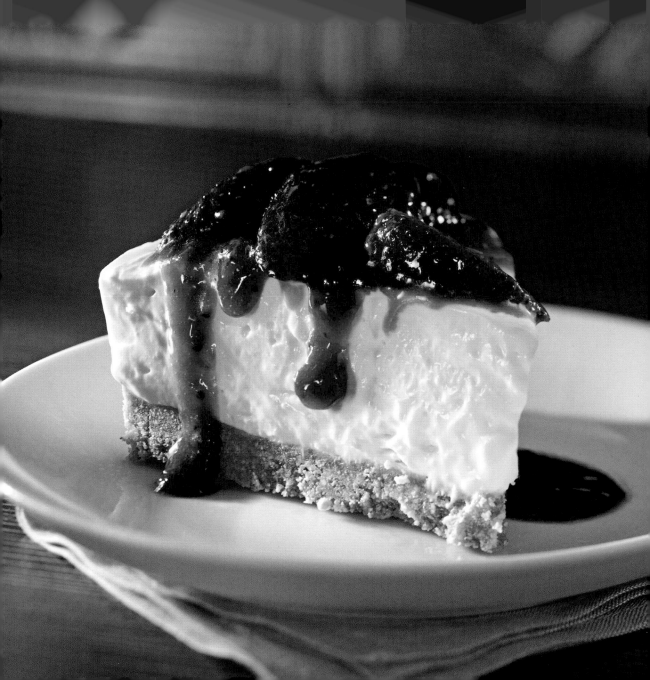

No–Bake Strawberry Cheesecake

This cheesecake technique is a less-complicated way to make a summer favorite.

makes 6 to 8 servings

CRUST
2 cups graham crackers, crushed
¼ cup brown sugar
½ cup butter, melted

FILLING
2 (8-ounce) packages cream
 cheese, softened
½ cup granulated sugar
1 teaspoon vanilla extract
1 tablespoon lemon juice
1 cup heavy cream

SAUCE
1 pound strawberries, hulled,
 sliced, and divided
⅓ cup granulated sugar
¼ cup water
1 tablespoon cornstarch
1 teaspoon butter

To make crust, combine graham cracker crumbs and brown sugar in a large bowl. Stir in ½ cup melted butter, and press into a 9-inch glass pie plate or 9-inch springform pan. Refrigerate.

To make filling, whip cream cheese, ½ cup granulated sugar, vanilla, and lemon juice in the bowl of a stand-up mixer until smooth and creamy. With machine running, slowly add cream until stiff peaks form. Pour into prepared crust, smooth top, and refrigerate for 2 hours or overnight.

Meanwhile, to make sauce, crush enough sliced strawberries to make ½ cup. In a medium-size saucepan, bring crushed berries, ⅓ cup granulated sugar, ¼ cup water, and cornstarch to a boil, stirring for 2 minutes or until thick. Add 1 teaspoon butter; stir until combined. Add remaining strawberry slices. Remove from heat, and let cool. Serve sauce over cheesecake slices.

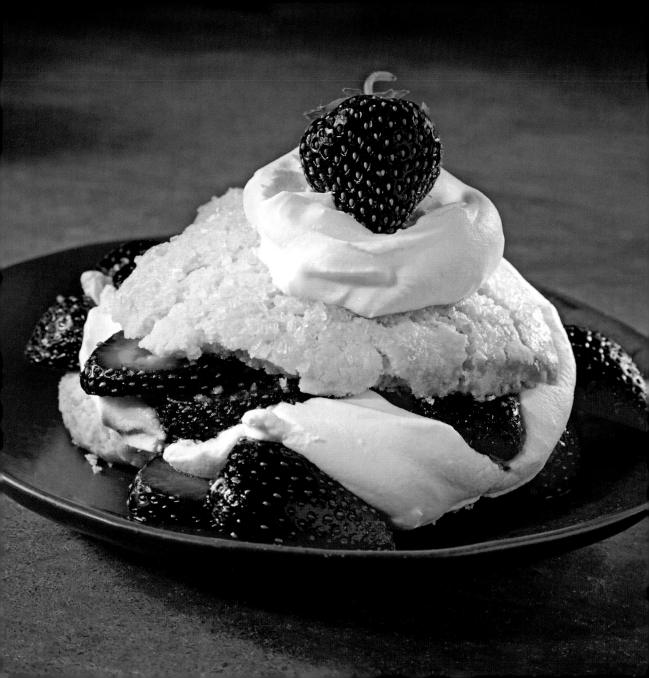

Strawberry Shortcake

This is the first dessert people think of during fresh strawberry season.
Combining cut strawberries with sugar creates a juice that soaks into the shortcake.
Save 6 of the perfect small strawberries to put on top.

makes 6 servings

INGREDIENTS

6 cups whole strawberries
¼ cup plus 6 tablespoons
 granulated sugar, divided
2 cups cake flour
1 tablespoon baking powder
½ teaspoon salt
½ cup unsalted butter,
 cut up and chilled
½ cup heavy cream
1 egg
1 egg white
1 tablespoon water
Coarse sugar
Store-bought whipped cream

Set aside 6 whole strawberries. Stem and cut remaining berries in half. Place half of berries in a medium-size saucepan with 3 tablespoons granulated sugar; cook over medium heat until softened and slightly thickened. In a bowl, combine remaining half of strawberries and 3 tablespoons granulated sugar; set aside.

Preheat oven to 425°. Line a baking sheet with parchment paper.

Combine flour, remaining ¼ cup granulated sugar, baking powder, and salt in the bowl of a food processor; pulse to combine. Sprinkle butter over flour mixture, and pulse until crumbly. In a small bowl, whisk together ½ cup cream and 1 egg. With machine running, slowly add cream mixture through chute; process just until dough forms a ball. Transfer dough to a floured sheet of wax paper. Pat dough to an even 1- to 2-inch thickness. Using a 3-inch cutter, cut dough into 6 rounds and place, sides touching, on prepared baking sheet. In a small bowl, stir together 1 egg white and 1 tablespoon water; brush tops with egg white mixture, and sprinkle heavily with coarse sugar.

Bake for 12 to 15 minutes or until lightly brown. Split with a fork. On the bottom half, layer cooked strawberries, a dollop of whipped cream, and sugared strawberries with juice. Top each with more whipped cream and 1 whole strawberry.

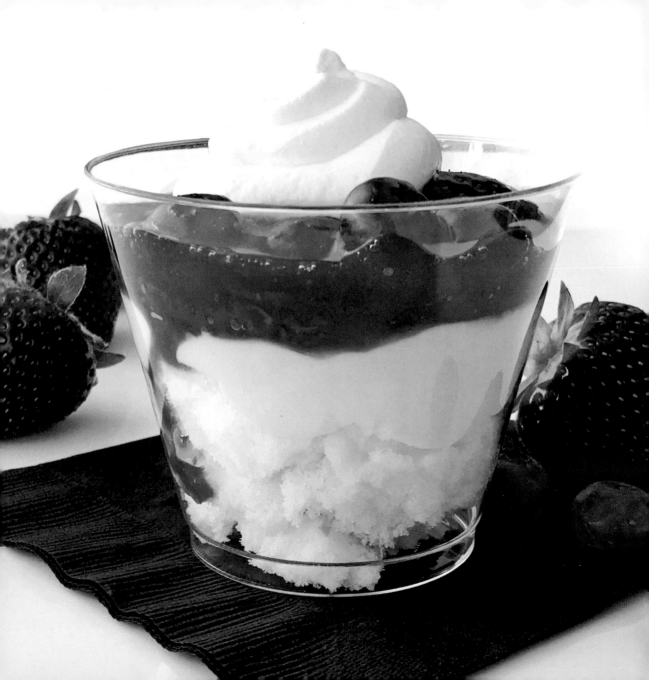

Patriotic Dessert for a Crowd

Serve this at your next backyard party.

makes 25 (8-ounce) servings

INGREDIENTS

5 cups sliced frozen strawberries, thawed

1 (3.4-ounce) package instant vanilla pudding mix

1 (8-ounce) package cream cheese, softened and at room temperature

¼ cup granulated sugar

¼ cup water

¼ cup lemon juice

2 tablespoons cornstarch

2½ cups (about 1 pint) fresh blueberries, rinsed and drained

2 cups heavy cream

2 tablespoons powdered sugar

2 store-bought angel food cakes, torn into bite-size pieces

Drain strawberries, reserving 1 cup juice. Set aside.

In the bowl of a stand-up mixer, prepare vanilla pudding according to package directions. Whisk in cream cheese; cover and cool in refrigerator.

In a large saucepan over medium heat, dissolve granulated sugar in ¼ cup water. Add lemon juice and 1 cup reserved strawberry juice; whisk in cornstarch until completely dissolved. Bring to a boil and stir until thickened. Add strawberries and blueberries, stirring to coat. Let cool.

In a medium-size bowl, whip cream until soft peaks form, and stir in powdered sugar; refrigerate to cool.

Place 25 (8-ounce) cups on serving trays. Fill each cup ½ way up with cake pieces. Top with 2 tablespoons pudding mixture, spreading and sealing to edges. Top with ¼ cup strawberry-blueberry mixture; refrigerate until ready to serve. Just before serving, top with 2 tablespoons whipped cream.

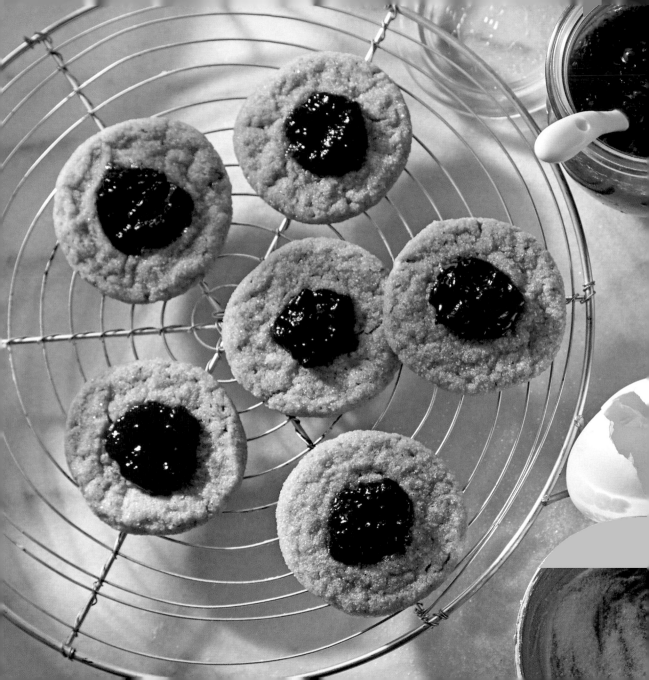

PB&J Cookies

These sweet-and-tasty cookies are gluten- and dairy-free. As a bonus,
they freeze well, so you can make several batches and store them for later.

makes 20 cookies

INGREDIENTS

1 cup smooth peanut butter
(such as Jif Creamy)
1 cup granulated sugar
1 egg
Pinch of salt
Low-Sugar Strawberry Jam (page
43), Strawberry Freezer Jam
(page 45), or store-bought
strawberry jam

In a large bowl, stir together peanut butter, sugar, egg, and salt until combined and smooth. Cover bowl with plastic wrap and refrigerate for 1 hour or until firm.

Preheat oven to 350°. Line a baking sheet with parchment paper.

Using a small ice-cream scoop, form 1-inch balls of dough; place 3 inches apart on prepared baking sheet. Make an indentation in each with your finger and fill with ¼ teaspoon jam.

Bake for 6 minutes or until tops are just firm. These cookies are very soft, get harder as they cool, and are golden brown on the bottom. Cool on a wire rack.

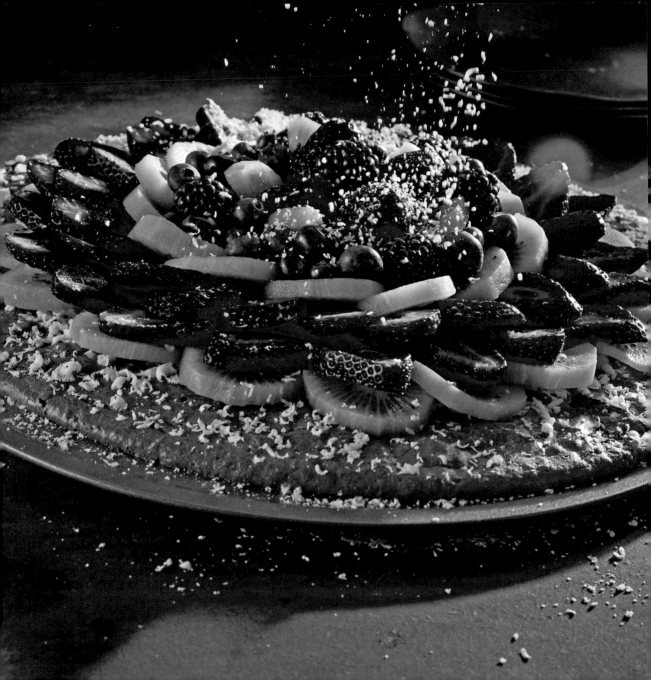

Pizownie

· ·

Pizza and brownies are popular favorites, so I combined the two ideas to create this fun dessert, using brownies for the crust, fruit slices in place of pepperoni, and white chocolate instead of mozzarella.

· ·

makes 1 (12-inch) pizza

INGREDIENTS
Vegetable cooking spray
¾ cup butter
4½ ounces
 unsweetened chocolate
2 cups granulated sugar
3 large eggs, lightly beaten
1 teaspoon vanilla extract
1½ cups unbleached
 all-purpose flour
2 ounces white chocolate, grated

TOPPINGS
Strawberries, sliced
Kiwi, sliced into rounds
Blueberries
Blackberries
Additional grated white chocolate

Preheat oven to 350°. Lightly grease pizza pan with cooking spray.

Melt butter and chocolate in top of a double boiler. Stir until mixture is glossy and smooth. Let cool for 1 minute.

Stir sugar, eggs, and vanilla into chocolate mixture. Transfer to a medium-size mixing bowl. Stir in flour until smooth. Spread batter evenly onto prepared pan. Bake for 18 minutes.

Sprinkle white chocolate over hot crust, and then add desired toppings. To serve, cut into 12 wedges.

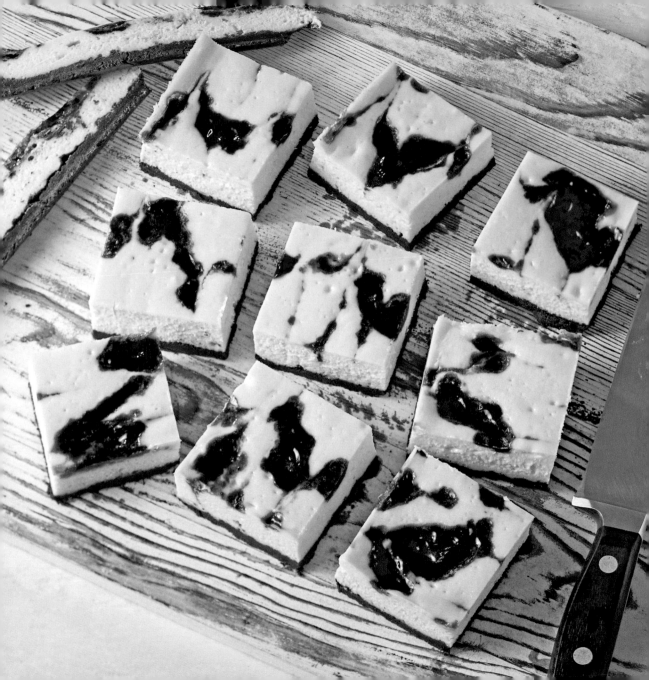

Strawberry–Double Chocolate Cheesecake Bars

These bars taste as good as they look. They can be frozen
for ease in cutting or to keep a nice dessert at the ready.

makes 12 bars

CRUST
½ cup granulated sugar
½ cup all-purpose or
 gluten-free flour
½ cup Dutch processed
 cocoa powder
⅛ teaspoon salt
5½ tablespoons unsalted butter,
 melted

CHEESECAKE
2 (8-ounce packages) cream
 cheese, at room temperature
¼ cup granulated sugar
1 teaspoon vanilla extract
1 cup white chocolate, chopped
 and melted
2 large eggs, at room temperature
½ cup store-bought seedless
 strawberry jam or reduced
 strawberry puree

Preheat oven to 350°. Line an 8x8-inch baking pan with
aluminum foil.

To make crust, pulse together ½ cup sugar, flour, cocoa
powder, and salt in the bowl of a food processor. Stir in
melted butter until combined and a sticky dough is formed.
Press dough into prepared pan and bake for 10 minutes.
Let cool for 15 minutes. Reduce oven temperature to 325°.

To make cheesecake, beat cream cheese and ¼ cup sugar in
the bowl of a stand-up mixer until light and fluffy. Add vanilla
and melted chocolate; beat on low until combined. Add eggs,
one at a time, and mix until just combined.

Pour cream cheese mixture evenly into prepared crust. Spread
jam or drop by teaspoonfuls over top; using a wooden skewer,
pull jam through cheesecake to make desired pattern.

Bake for 30 minutes or until center jiggles just slightly.
Let cool (about 2 hours) and refrigerate for 2 hours.
Store, covered, in the refrigerator up to 4 days.

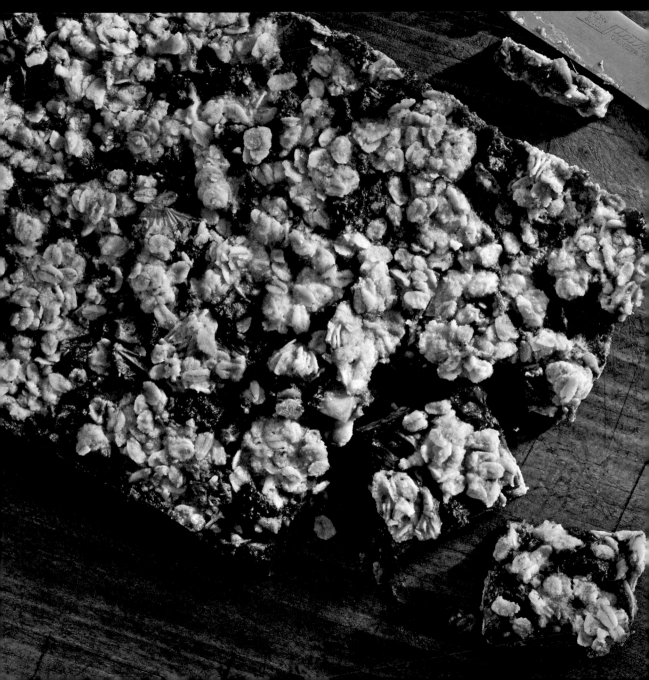

Strawberry Oat Bars

· ·

These healthy bars can also be made gluten- and dairy-free.

· ·

makes 16 bars

INGREDIENTS
1½ cups rolled oats
¾ cup all-purpose or
 gluten-free flour
½ cup brown sugar
2 teaspoons lemon zest
¼ teaspoon baking powder
¼ teaspoon salt
¾ cup cold unsalted butter or
 ¾ cup coconut oil

FILLING
2½ cups strawberries, chopped
 into ¼-inch chunks
7 tablespoons store-bought
 strawberry jam
½ teaspoon vanilla extract

Preheat oven to 375°. Line an 8x8- or 7x11-inch baking pan with aluminum foil.

To make bars, combine oats, flour, brown sugar, zest, baking powder, and salt in a large mixing bowl. Cut in butter with a pastry blender, and mix until a crumbly dough comes together. Gently press ⅔ oats mixture into bottom of prepared pan. Bake for 10 to 13 minutes or until edges start to turn brown.

Meanwhile, to make filling, combine strawberries, jam, and vanilla in a medium-size bowl. Spread filling over baked crust, and then sprinkle remaining ⅓ oats mixture over filling. Bake for an additional 25 to 30 minutes or until top is lightly brown and filling is bubbly. Cool bars, and refrigerate for 2 hours before cutting. Store in an airtight container in the refrigerator up to 4 days, or freeze.

Index

EXPLORE THE ENTIRE SERIES OF
Nature's Favorite Foods Cookbooks!

978-1-59193-907-8
$16.95

978-1-59193-847-7
$16.95

978-1-59193-232-9
$16.95

978-1-64755-184-1
$16.95